POSTCARD HISTO

Mapleu

D0764851

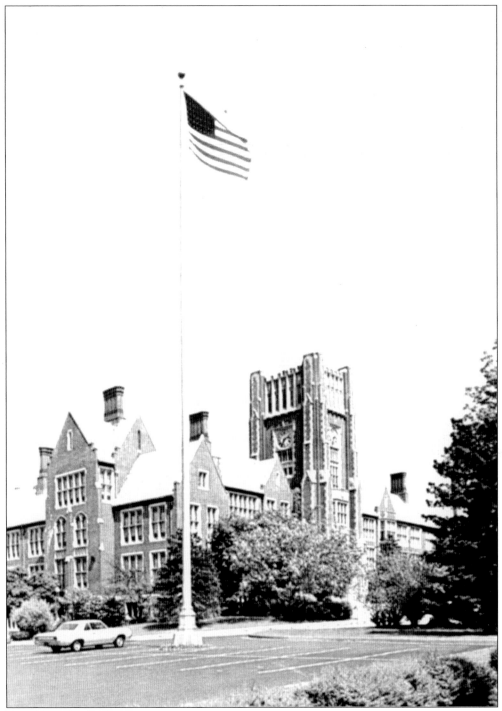

Columbia High School serves Maplewood and South Orange.

POSTCARD HISTORY SERIES

Maplewood

John F. Harvey

ARCADIA

Copyright © 2003 by John F. Harvey
ISBN 0-7385-1347-4

First published 2003

Published by Arcadia Publishing,
an imprint of Tempus Publishing Inc.
Portsmouth NH, Charleston SC, Chicago,
San Francisco

Printed in Great Britain

Library of Congress Catalog Card Number: 2003110751

For all general information, contact Arcadia Publishing:
Telephone 843-853-2070
Fax 843-853-0044
E-mail sales@arcadiapublishing.com
For customer service and orders:
Toll-free 1-888-313-2665

Visit us on the Internet at www.arcadiapublishing.com

CONTENTS

Acknowledgments 6

Introduction 7

A Brief History of Postcards 9

1. Homes and Street Scenes 11

2. Commercial Maplewood 55

3. Getting Around 73

4. Public Service 81

5. Halls of Learning 93

6. Places of Worship 103

7. Maplewood at Play 115

ACKNOWLEDGMENTS

First of all, I would like to express my appreciation to the Durand-Hedden House and Garden Association, along with Jack Bausmith and Harold Wiseman, who did such a terrific job documenting the history of Maplewood in their 1998 Arcadia publication in the Images of America series. Their documentation and the time they shared with me to increase my knowledge of this wonderful town were invaluable. Also, hearing their stories from a lifetime as residents of Maplewood was immensely enjoyable.

I would also like to thank Susan Newberry and the Durand-Hedden House and Garden Association for their initial invitation to develop a postcard history and presentation on Maplewood. The group's support and enthusiasm about preserving the history of Maplewood was energizing. I would also like to thank Nancy Heinz-Glaser for her invitation to facilitate the Bagel Bites and Sound Bites series in South Orange and for introducing me to the Montrose Historic District Preservation Committee. While the focus of these conversations was our good neighbor, South Orange, the storytelling approach to collecting historical perspectives was tremendously helpful to me.

David Oldfield and the Transform Team also deserve mention. David Oldfield, Courtney Harrison, Alicia Mandel-Hickey, Julie Kozelian, Bob Franco, Susan Luckett, Chris Yates, and Sonia Narong have been valuable guides in encouraging me to escape my comfort zone—as this project was clearly outside of my usual path.

Finally, I lovingly dedicate this effort to the main characters in my story: Helen, my partner in crime, who is not only an incredible person but the best-looking woman I have ever seen at a postcard show; John, a wonderful son and fellow rugger; Corinne, my truth teller; Janean, my heartfelt activist; and Julia, who still serves as my little princess. They are the gift of my life and the key to surviving this year of incredible transition.

INTRODUCTION

The history of Maplewood is well documented. The area was originally home to the Lenni Lenape Indians. According to the Wallum Ollum, the religious history of the Lenni Lenapes, these Native Americans settled in New Jersey for at least 10,000 years.

The first non-native settlers of the area, known over the years as Jefferson Village, Middleville, Hilton, South Orange, and subsequently Maplewood, arrived *c.* 1866. The settlers—mostly English—purchased a tract of land from the Lenni Lenapes that was situated at the foothills of South Mountain. Today, Maplewood is bounded by the towns of Newark, Irvington, South Orange, Vauxhall (Union), and Millburn.

Maplewood has been noted for many things over the years, some extraordinary and others ordinary. A number of famous people lived or visited here. The notables include the inventor Seth Boyden (1788–1870), who made the first malleable iron, daguerreotypes (photographs), and patent leather. He lived in Maplewood, and a school was named after him. Also, Timothy Ball, a cousin of George Washington, was a host to the future president at his home on Ridgewood Road (it still stands today). As a boy, Theodore Roosevelt spent summers at the estate of his aunt and uncle Laura and Cornelius Van Schaick Roosevelt. Also of note was local resident Asher B. Durand (1796–1886), who lived at the corner of Ridgewood and Durand Roads. A plaque marks the site of the residence of this world-famous engraver and painter, who was part of the Hudson River school of painting. Durand's work sits in collections and museums around the world.

Maplewood's story is also defined by the many more people over the years who have not gained the same level of public notoriety. The postcards in *Maplewood* tell the story of everyday people. The cards and the messages provide a glimpse or what life was like in the early to mid-1900s, when postcards were a significant means of everyday communication. The people photographed in many of the cards are unidentified. Many of the buildings still exist today. Some, however, were victims of expansion and modernization. The year 1921 marked the beginning of the greatest period of building and expansion, as the town's population grew from 5,000 to 21,000 in the next decade.

Maplewood has been known over the years as a place that welcomes diversity. It is not nirvana. There are still issues, but significant energy is clearly focused on celebrating diversity and fostering a sense of community. This is not new. In the late 1800s, there were at least five religious congregations (Methodist, Baptist, Episcopalian, Catholic, and Protestant) located in Maplewood, which was a very small town at the time. In fact, the original settlers mixed relatively well with the Native Americans in their escape from English oppression. More recently, *Money* magazine

heralded Maplewood as "one of the best places to live" for people living nontraditional lives, people of the arts and business, and people of many different religious and ethnic backgrounds.

When my family first arrived to Maplewood via Long Island and Philadelphia in 1984, we had not heard of the town. We were typical New Yorkers. We were initially attracted by the housing (no two homes are the same), the greenery and parks (well planned over the years), and the fact that Maplewood had a small-town feel but was within a 30-minute car ride (without traffic) to New York City. It also had this incredible village, which was a throwback to the 1800s. The town center was a small, three-city-street long strip of commerce and a place to meet friends and neighbors.

What kept us in Maplewood, however, was the people. Maplewood residents are generally friendly. They look you in the eye, and they ask how you are doing (and mean it). The collection of historic postcards included in this book is a glimpse into the lives of everyday people. Some of the postcards show the same type of people who live in Maplewood today. I hope you enjoy these postcards and the stories contained in each picture.

—John F. Harvey

A BRIEF HISTORY
OF POSTCARDS

Historical postcards are initially intriguing because of the pictures—the views represented on the front of the postcards. Looking at familiar places from everyday life almost 100 years ago is magnetic. However, the day-to-day dialogue captured on the cards is also interesting. The messages range from the mundane on a card sent from a son, Joe, who wrote to his parents, Mr. and Mrs. B. Smith in Bethlehem, Pennsylvania, in 1943, "Hi ya, the beer is just as cold here. See ya' next week," to emotional commentary from a convalescing woman, Gladys, who wrote to a close friend in Madison, Connecticut, in 1923, "I'd like to think I'll make it back to M [Madison], but I think Heaven is my next stop."

The first postcards as we know them today appeared in 1869; however, lithograph prints and woodcuts preceded the postcard format. This marked the pre-postcard era, which lasted from 1840 until 1869. Typically, comics, valentines, and music were the pictures of choice in this era, although patriotic covers were popular during the Civil War period.

The first postal card appeared in 1869 in Hungary. This marked the start of the pioneer era in postcards, which lasted from 1870 to 1898. This period was noted by the first regularly printed card (Franco-German War in 1870), the first advertising card (Great Britain in 1872), the earliest known "exposition card" (1873), and the first multicolored card (Heligoland in 1889). The cards of this era were identified by several characteristics; the back of the card is undivided, they contain a byline "Authorized by Act of Congress," and the stamped cards have a Jefferson head stamp.

The private mailing era of postcards began in 1898, when the federal government gave private publishers permission to print and sell postcards. The cards included an inscription "Private Mailing Card Authorized by Act of Congress on May 19, 1898." Greetings could only be written on the front of these cards with the back side reserved for postage and a postal address. It cost 1¢ in postage to mail a card, creating the term "penny card."

In 1901, the federal government granted the use of the words "post card" to be printed on the backs of postal cards and dropped the previous authorization inscription. Writing was still limited to the front of the card until 1902 in England, 1904 in France, 1905 in Germany, and 1907 in the United States.

These modifications led to the divided back era, which lasted from 1907 to 1915. At this time, the majority of U.S. postcards were printed in Germany, where printing methods were regarded as the best in the world. This led to some translation issues, as seen on some of the cards in this book. The divided back made it possible to fit an address and a lengthier message on the back. The availability of cards at this time and the ability to carry a longer message led to postcards as the most popular means of distance communication at the time. This was the golden age of postcards.

Political strains between the United States and Germany in 1915 brought about the end of the golden age of postcards. In the early modern era, also known as the white border era (from 1916 to 1930), imported cards from Germany ceased, and U.S. printers tried to fill the void. However, many of the cards at this time were of poor quality and were mostly reprints of earlier cards. Cards from this era had a white border around the picture area.

The linen card era began in 1930 and lasted until *c.* 1940. Improved technology at the time allowed printing on linen paper containing high rag content. Cheap inks were used at this time, creating cards with very bright and vivid colors. These cards were very popular with collectors of roadside America, blacks, comics, and advertising, all prominent subjects of cards printed during this era.

The last and current era of postcards is called the photochrome era, which started in 1939 with a Union Oil series of postcards. These cards are sometimes called modern chromes, and they are the most popular cards today. Despite the increase in cost from 1¢ to 23¢, postcards continue to be a popular means of communication, especially for vacationers. Collectively, postcards provide an excellent storyline to how much has changed and how much has remained the same in America and the world over the years.

One

HOMES AND
STREET SCENES

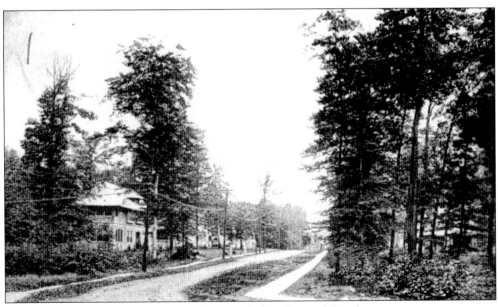

Woodland Road is seen in a view looking north from Durand Road.

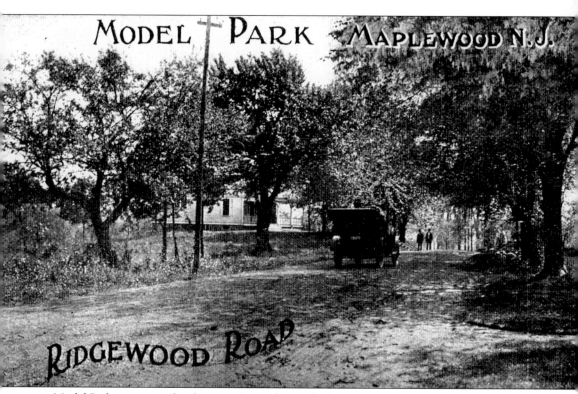

Model Park was a new development in Maplewood when this card was mailed in 1909. The card describes Maplewood as the "garden spot of Essex County," a title earned by Maplewood's early tree commission.

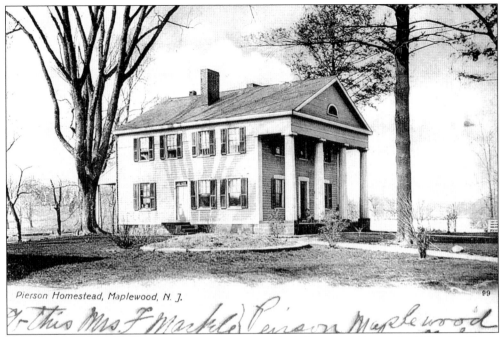

Pierson Homestead, Maplewood, N. J.

Tr This Mrs F Markle Pierson Maplewood

The Greek Revival home pictured on this card was built by Lewis Pierson in 1843. A mill was added 12 years earlier to serve the agricultural community by marketing and milling feed and grain. The Pierson estate comprised about 250 acres that were purchased in the 1760s. Today, the building at 693 Valley Street is a private residence and the mill has been converted into commercial retail and office space.

This 1902 view of the Pierson home shows the mill to the left of the house. Pierson also diverted the Rahway River to create Pierson's Pond, which provided an energy supply for his business and served as a favorite ice-skating destination for young Maplewood residents.

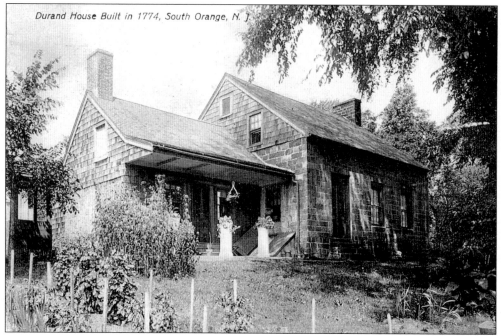

Durand House Built in 1774, South Orange, N. J.

The Durand House was built in 1774 and is located at 525 Ridgewood Road. The card inaccurately identifies the town as South Orange, a common translation error, as postcards were printed in Germany at the time this card was mailed in 1908.

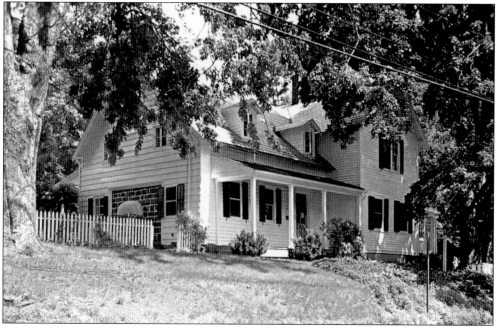

A more recent photochrome postcard of the Durand House shows the current home of the Durand-Hedden House and Garden Association, which offers a glimpse into Maplewood's rural past with programs such as open-hearth cooking.

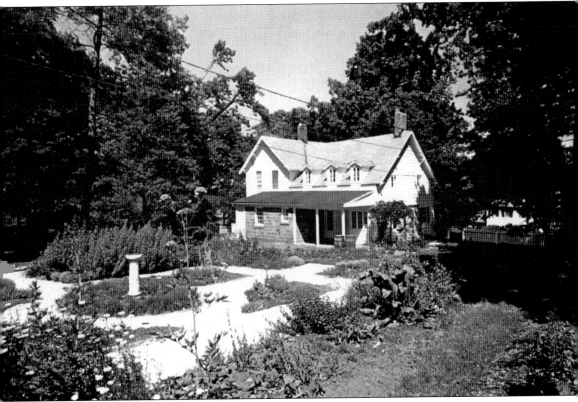

A modern view of the rear of the Durand-Hedden House shows the herb garden at this pre–Revolutionary War house.

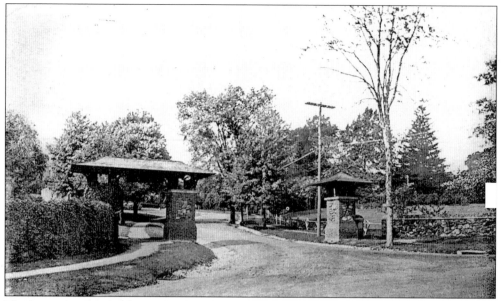

The homes on Roosevelt Road and in the Roosevelt Park section of town sit on land that was once the Roosevelt estate, owned by Theodore Roosevelt's aunt and uncle Laura and Cornelius Van Schaick Roosevelt.

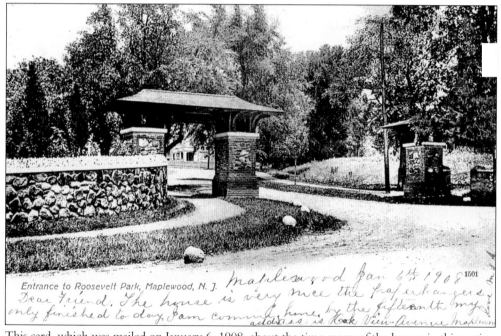

Entrance to Roosevelt Park, Maplewood, N. J.

This card, which was mailed on January 6, 1908, about the time many of the homes in this section were built, offers, "Dear Friend. The house is very nice, the paperhangers only finished to day, I am coming home by the fifteenth, my address is Oak View Avenue in Maplewood, love M.L.J."

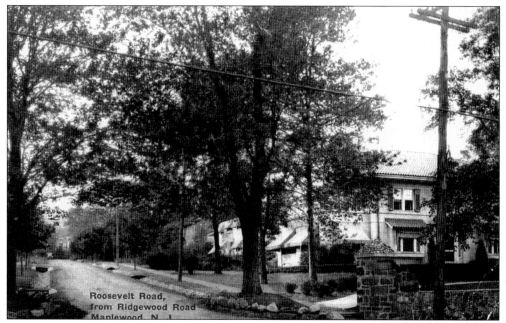

The original entrance to the Roosevelt estate offers a grand entrance to Roosevelt Road. The home on the right is located at 551 Ridgewood Road.

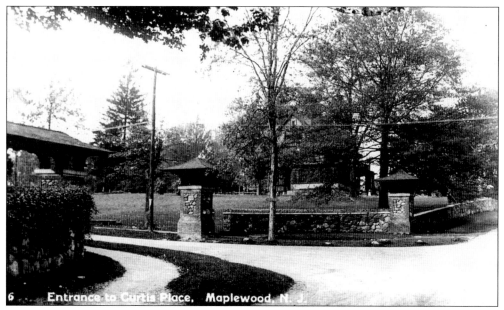

The homes developed on Curtis Place and in the immediate area were built in the early 1900s by William Curtis, who married a Roosevelt descendant.

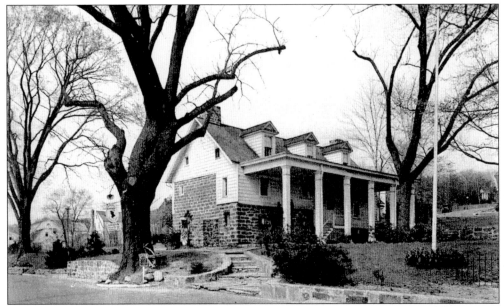

The Timothy and Esther Ball House was built in 1743, just down the road from the Durand–Hedden House on Ridgewood Road. The small upper window on the left side of the house is where the owners' nephew George Washington slept when he visited the home during the Revolutionary War.

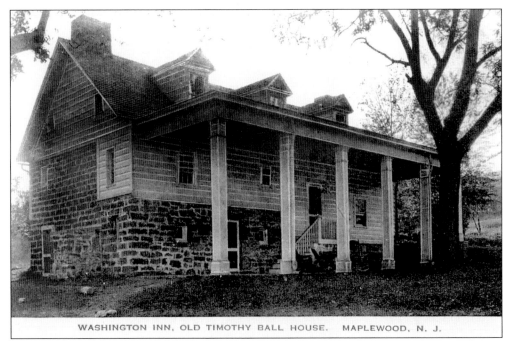

WASHINGTON INN, OLD TIMOTHY BALL HOUSE. MAPLEWOOD, N. J.

For a time, the Timothy and Esther Ball House served as the Washington Inn. Today, the house serves as a residence and is located at 425 Ridgewood Road. It is arguably the best known of Maplewood's historic homes.

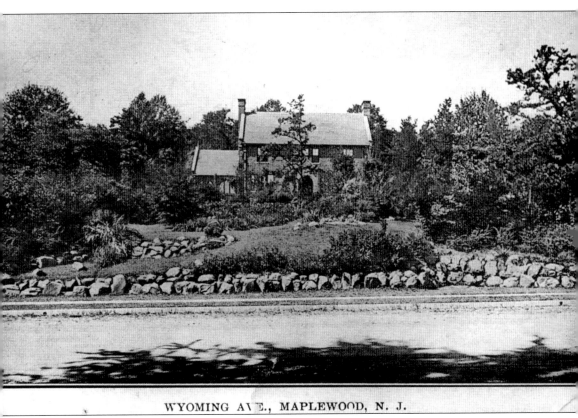

WYOMING AVE., MAPLEWOOD, N. J.

Mailed in 1917, this card shows a house on Wyoming Avenue.

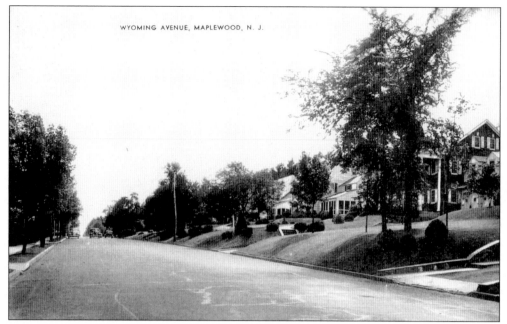

Looking west, this view of Wyoming Avenue shows some classic automobiles in the distance.

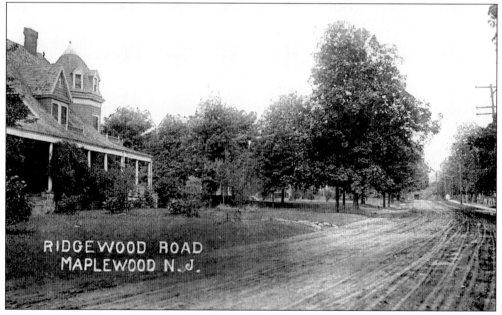

Ridgewood Road served as a popular thoroughfare between Newark and Morristown to the west when this card was printed in the early 1900s. The home on the left, which stands today, is located at 625 Ridgewood Road. The sentiment of many Maplewood residents is captured in the 1910 message on this card: "Oh, what a lovely place Maplewood is!'"

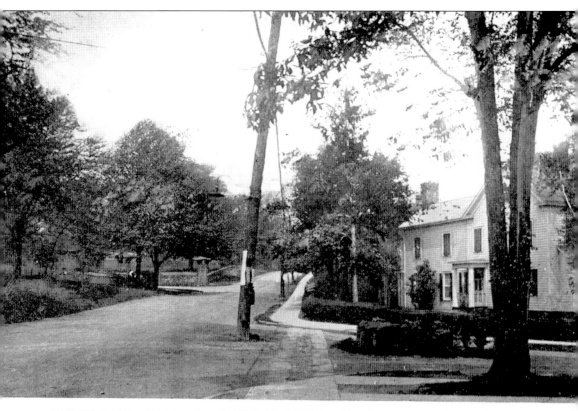

RIDGEWOOD ROAD, LOOKING NORTHEAST, Maplewood, N. J.

Looking north, this view of the intersection of Ridgewood Road and Baker Street shows the residence today at 5 Baker Street. This home was built in 1776 and was called "Necessity Corner." It was the first school in Maplewood (Jefferson Village at the time). Over the years, it served as a tavern, a meetinghouse, and a general store.

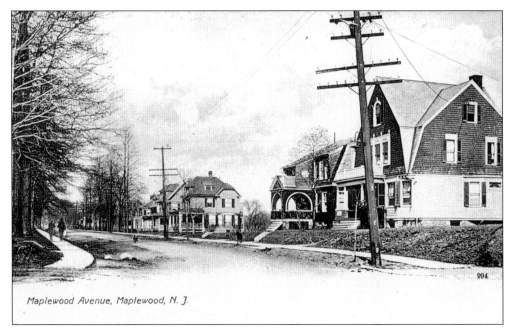

Maplewood Avenue, Maplewood, N. J.

Another view of Maplewood Avenue shows a couple on the left heading northeast. The residences at 140, 138, and 130 Maplewood Avenue are shown. The building at No. 140 is occupied by a dentist's office today.

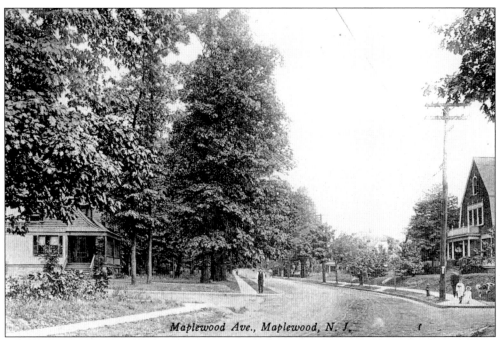

Maplewood Ave., Maplewood, N. J.

Maplewood Avenue is shown in a view looking away from the village toward the northeast. The home on the left is 139 Maplewood Avenue. Note the man in the middle of the picture and the children to the right. According to the message on the card, Gertrude Yeufel was an early resident at this address.

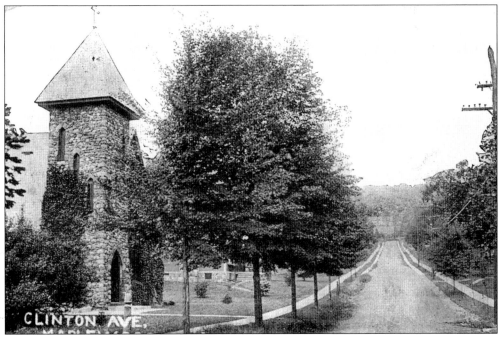

This early scene looking northwest up Clinton Avenue shows the original St. George's Episcopal Church on the left. The church was ultimately razed, and homes at 16 and 18 Clinton Avenue occupy the lot today.

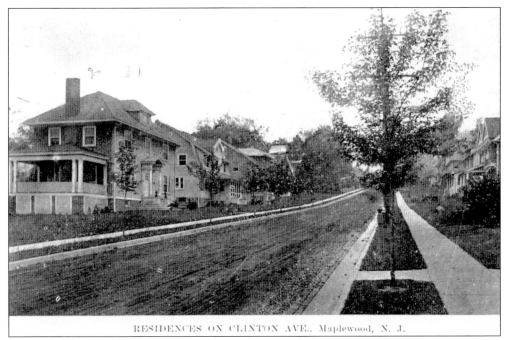

RESIDENCES ON CLINTON AVE., Maplewood, N. J.

The 1913 notation on this card indicates that 26 Clinton Avenue was the residence of Lila Smith at that time.

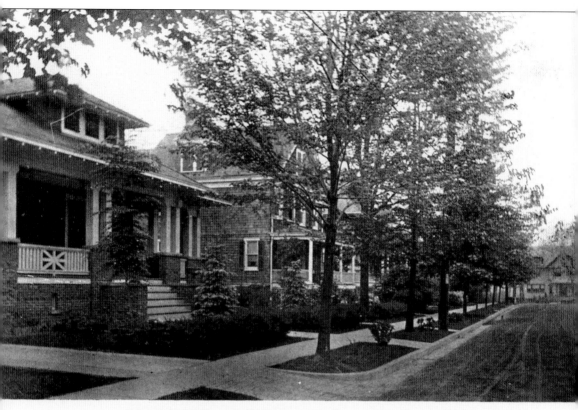

RESIDENCES ON CLINTON AVE., Maplewood, N. J.

Looking southeast, this early view of Clinton Avenue shows the residence at 9 Clinton Avenue. The home looks much the same today. The building at the end of the street is the residence at 608 Ridgewood Road.

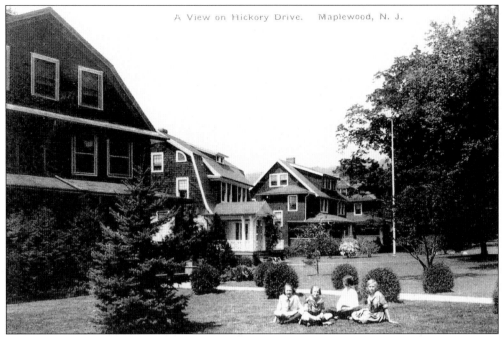

A View on Hickory Drive. Maplewood, N. J.

Neighborhood kids enjoy a comfortable day in front of 22 Hickory Road. The card was mailed in 1908.

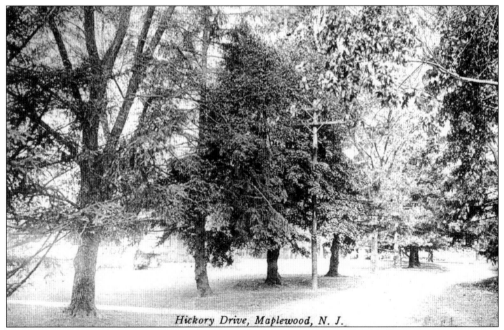

Hickory Drive, Maplewood, N. J.

This view supports Hickory Road's place as one of the more scenic roads in Maplewood. In a 1909 note to a friend in East Rutherford, New Jersey, Mildred wrote, "Janet, we took a walk after church yesterday and saw this fine road. Love to all from Mildred."

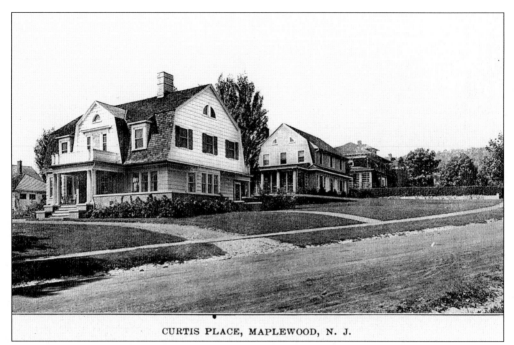

CURTIS PLACE, MAPLEWOOD, N. J.

This view on Curtis Road shows the residence at 10 Curtis Place, with South Mountain in the background.

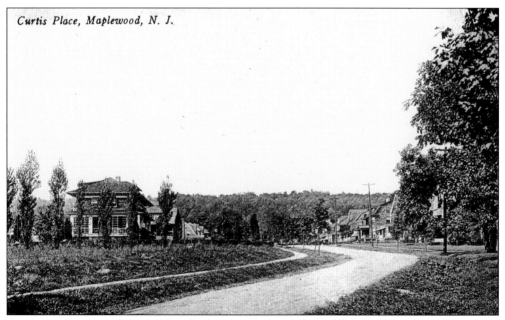

Curtis Place, Maplewood, N. J.

Another early view of Curtis Place, looking west, shows the residence at 18 Curtis Place.

This view of 45 and 43 Ridgewood Terrace was taken from the corner of Wyoming Avenue. The street is located in a development of 175 homes built by Edward C. Balch. The fact that no two homes were built with the exact same plan is consistent with the construction of most homes in Maplewood.

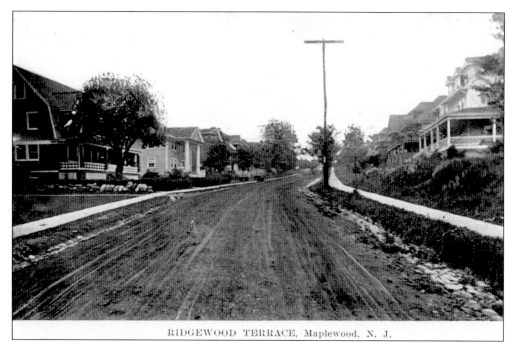

RIDGEWOOD TERRACE, Maplewood, N. J.

This 1902 scene of Ridgewood Terrace is facing northwest, with the current Morrow Methodist Church in the opposite direction. The home on the left with the two white pillars is 6 Ridgewood Terrace.

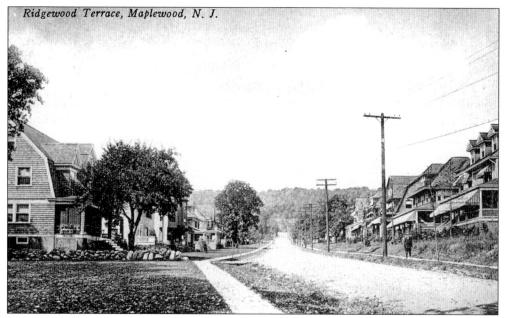

Ridgewood Terrace, Maplewood, N. J.

This northwesterly view of Ridgewood Terrace shows South Mountain in the distance. The home on the far right is 5 Ridgewood Terrace.

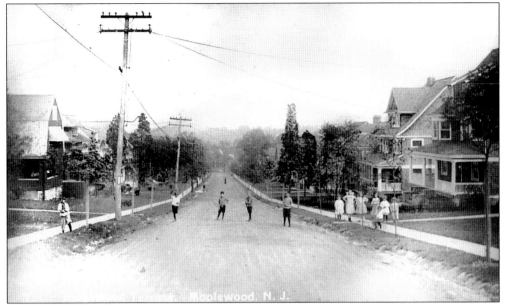

This faded view shows a group of kids playing in front of 30 Ridgewood Terrace, on the right.

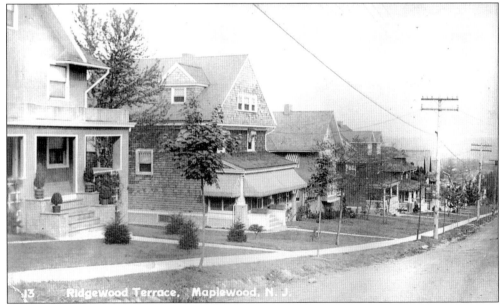

Ridgewood Terrace was created when Edward C. Balch erected 41 homes here, in addition to another 175 homes he built in Maplewood. The homes on the left on this postcard are located at 45 and 43 Ridgewood Terrace.

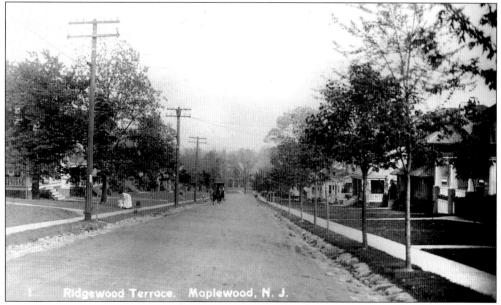

In a view looking east on Ridgewood Terrace, a mother is seen with her child, a horse-drawn buggy is coming up the road, and Morrow Memorial Methodist Church is seen in the distance.

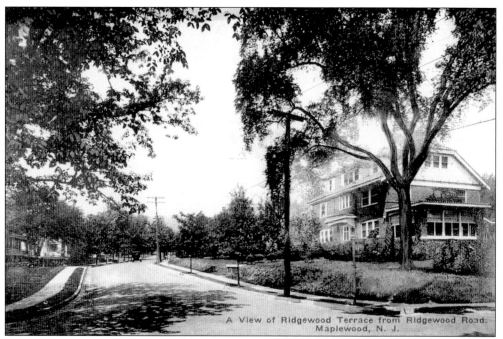

A view of Ridgewood Terrace, looking west, shows the home at 1 Ridgewood Terrace on the right. During early Fourth of July celebrations, the residents of Ridgewood Terrace were known for the terrific floats they built for the parade.

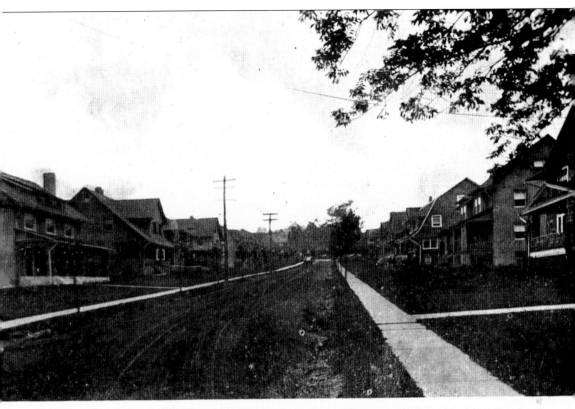

4 WINTHROP PLACE, Maplewood, N. J.

Winthrop Place is situated in a section once referred to as Maplewood Heights. This northwesterly view shows the residence at No. 4 on the left. According to local historians, Winthrop Place and Ridgewood Terrace residents built the best floats, as was the custom, in early Maplewood Fourth of July parades.

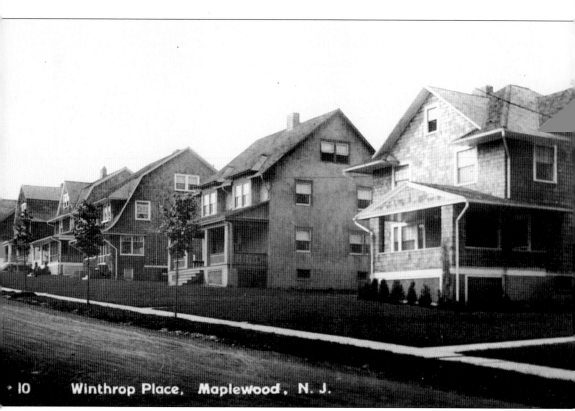

In a view looking northwest, homes at 3 and 5 Winthrop Place are seen in this early postcard. According to the note on the card, dated 1915, 14 Winthrop Place was the home of the mother of Noble L. Colfax at that time.

Postcards such as this one were used for providing mailing addresses and telephone numbers, as seen in the back view below. Interestingly, while the card indicates the address is 11 Winthrop Place, the house is actually located at 18 Winthrop Place.

Eleven Winthrop Place
Maplewood
New Jersey
'Phone - So. Orange 852-W

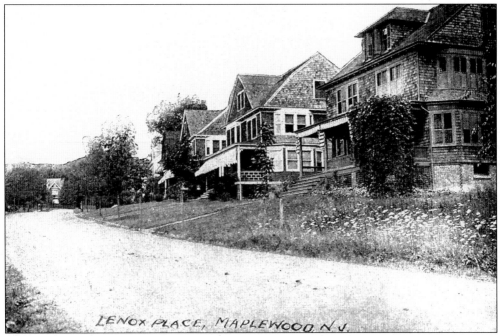

This view of Lenox Place, facing Ridgewood Road, shows residences at No. 9 and No. 11 on the right. The home in the distance at the end of the road is 603 Ridgewood Road.

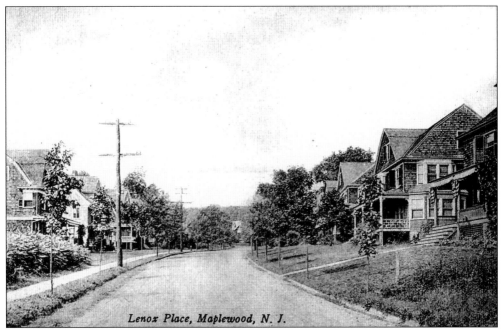

This postcard also shows 11 Lenox Place. The bunting is most likely in preparation for the Maplewood Fourth of July celebration, a tradition that began in 1904.

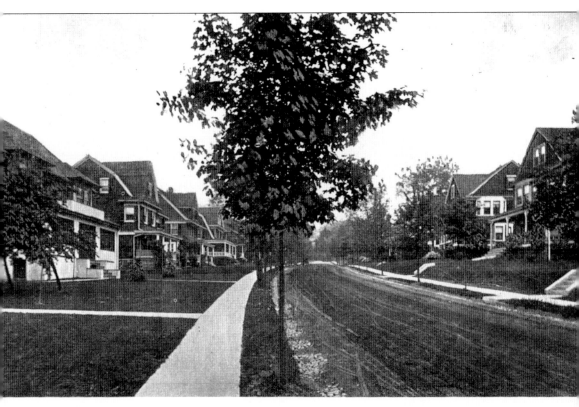

LENOX PLACE, Maplewood, N. J.

This view of Lenox Place was taken from Maplewood Avenue. The first house on the left is at No. 10, although renovations over the years have hidden many of its details.

This view of Maple Avenue shows some early Maplewood homes on the left that were subsequently razed prior to 1902 to make room for Maplewood Middle School (originally Ricalton Junior High School). These homes represented some of the largest homes in Maplewood at the time. This postcard, along with many others at this time, was printed by Garrett Byrnes, a Maplewood pharmacist, to sell in his store on Maplewood Avenue.

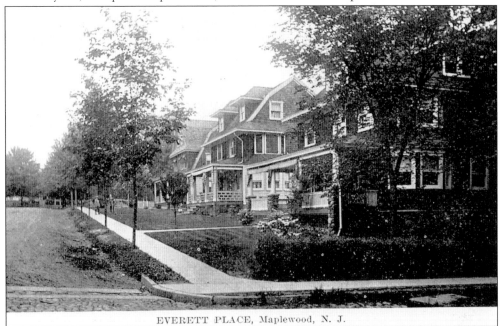

EVERETT PLACE, Maplewood, N. J.

In a view looking north from Baker Street, a couple of neighborhood boys, one with a scooter and one wearing a cap, are on the sidewalk in front of No. 10. The house on the right is situated at 12 Everett Place.

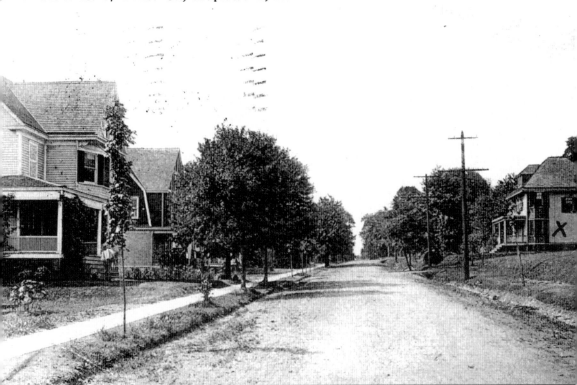

In a view looking east on Burnett Street, the house on the right is marked with an *X* to identify the home of C.W.S., who sent the card in 1911. In addition to Easter greetings, the message on the back offers, "Wish we might see you coming up the steps some bright day. Why not?" The recipient was an acquaintance, Miss L.F. Philbrook, of Middletown, Connecticut.

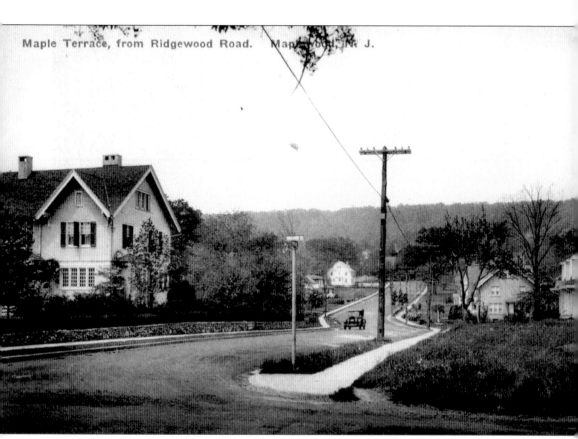

Maple Terrace, from Ridgewood Road. Maplewood, N. J.

This view looking northwest toward South Mountain shows some classic cars between homes at 32 Maple Terrace (in the distance) and 657 Ridgewood Road (on the left).

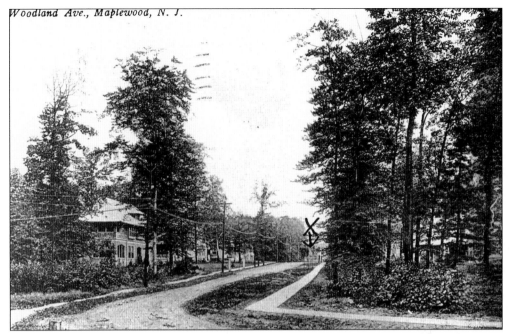

Woodland Ave., Maplewood, N. J.

This street is actually Woodland Road (not Woodland Avenue) and the view is looking in a northerly direction. When the photograph was taken, Durand Road had not yet been cut through on the left. The sender used an *X* to note where his house was located when the card was mailed in 1911.

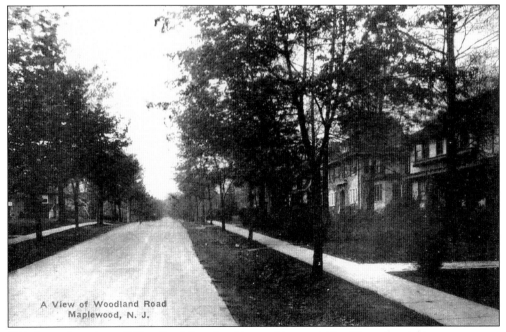

A View of Woodland Road
Maplewood, N. J.

This is another view of Woodland Road, with a residence at No. 30 on the right.

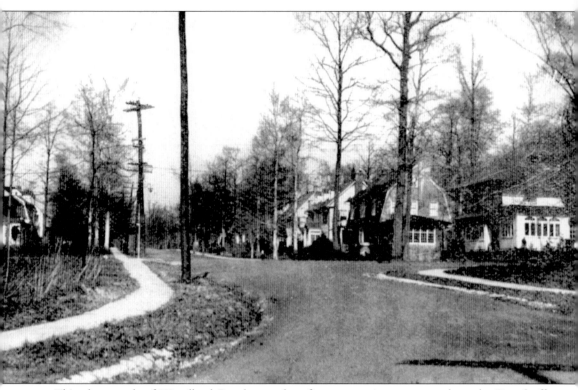

This photograph of Woodland Road was taken from a spot just next to where the Burgdorff Cultural Center is located today. The house to the right is located at 11 Durand Road, and the next house is 42 Woodland Road.

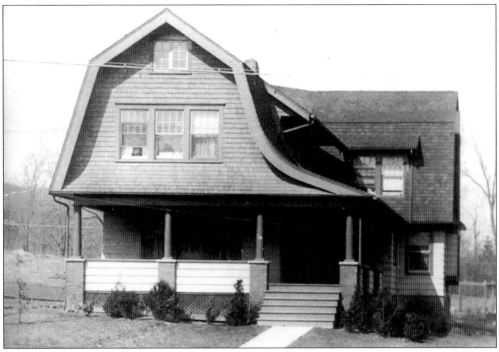

Located at 19 Euclid, this home is where Hilda Cross was born in 1913.

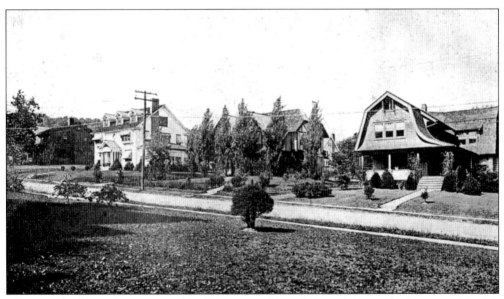

This view looks northwest across Euclid Avenue. From left to right are the homes at No. 25, No. 21, and No. 19. The card was mailed in 1919.

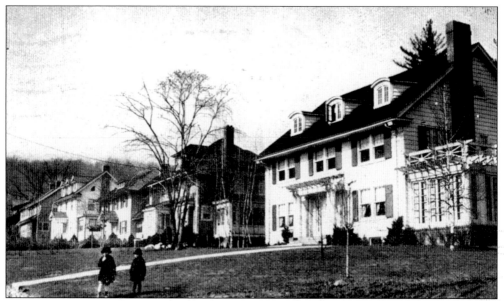

This hand-colored view of 91 Durand Road shows two children wondering what all the fuss is about *c.* 1931.

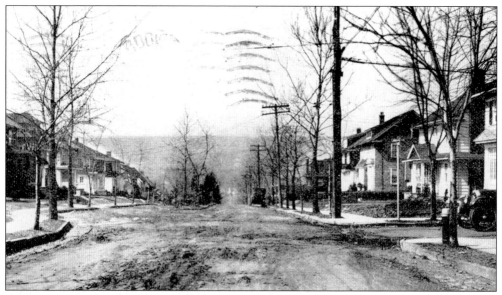

This is a hand-colored card of Park Avenue in a view facing north. South Mountain is seen in the rear, and the first home on the right is 41 Park Avenue. Notice the classic automobile coming out of Osborne Terrace on the right.

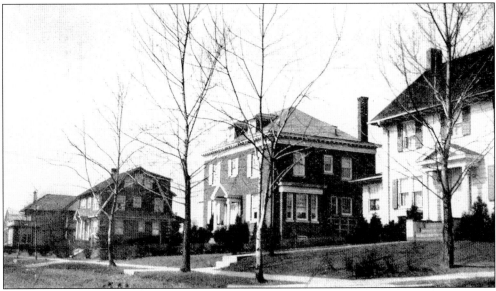

This hand-colored view of Burnett Terrace shows several residences *c.* 1908.

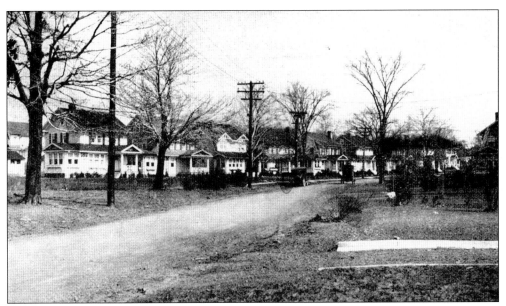

Tuscan Road is seen in a view facing east from Prospect Street. The location is near Prospect Presbyterian Church.

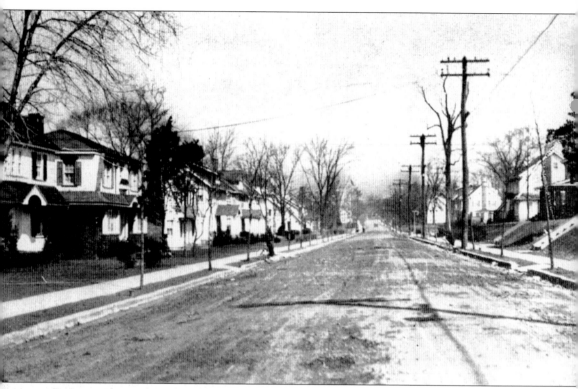

Facing northeast, this view of North Terrace shows homes at No. 25 and No. 23 on the left. The flag flying in front of Columbia High School can be seen in the distance.

This residence at 45 North Terrace appears on a postcard that was typically used as personal stationery or to share holiday greetings in the 1920s and 1930s.

This view of Prospect Street, facing northeast, provides a clear view of homes at 615, 613, and 611 Prospect Street near Oakview Avenue.

In this view of Edgewood Place, from the intersection of Kensington Terrace, South Mountain is seen in the distance. The building with the flagpole at the end of the street is the old Hammond Map Building on Valley Street. The home on the right is at 11 Edgewood Place.

This was a holiday postcard from the Mertens, the residents of this home at 5 Osborne Terrace, at the corner of Girard Place.

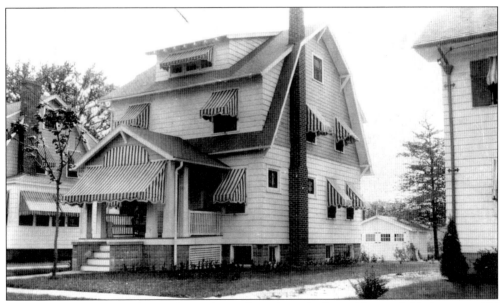

Awnings were the rage for Walter and Martha Wiegand, the residents of this home at 137 Oakland Road, as well as for their neighbors.

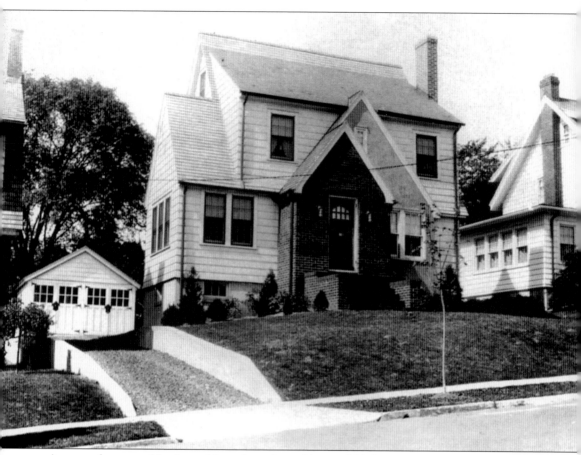

A personal note card is pictured here from the residents of this home at 16 Collinwood Drive.

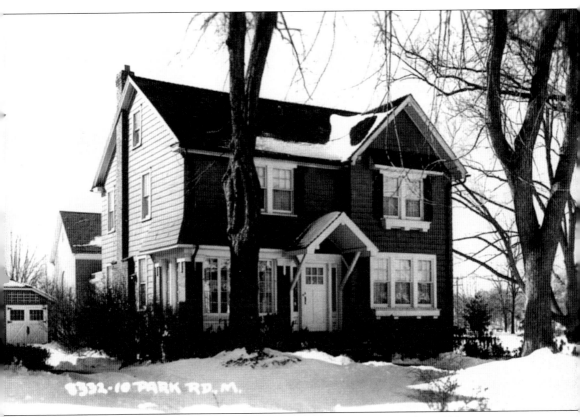

A photographic postcard promotes the sale of this home at 10 Park Road in 1932.

This postcard was used to market the sale of this home at 48 Kendall Avenue in June 1925.

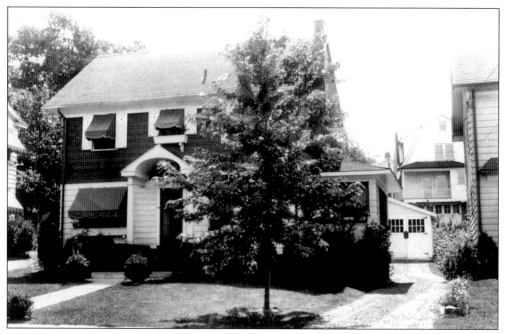

As indicated on the postcard, this house at 72 Kendall Avenue was the residence of Walter Davis.

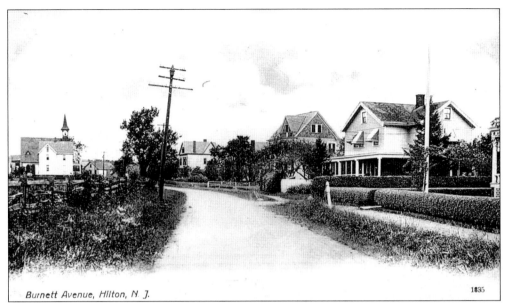

Burnett Avenue, Hilton, N. J.

1835

In this view of Burnett Avenue, the steeple of Hilton Christian Church is seen in the distance. The church was built in 1875 and became the First Congregational Christian Church of Maplewood in 1936.

This is a view of Boyden Avenue in the Hilton section of Maplewood.

This is a 1914 view of Academy Street (now Tuscan Road) in the Hilton section of Maplewood.

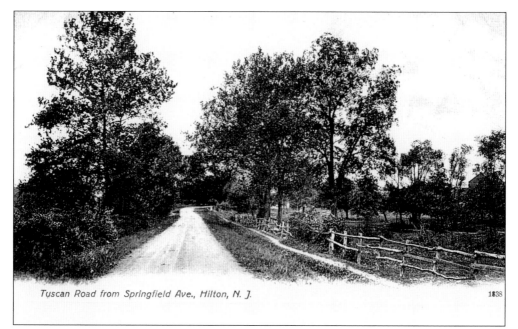

Tuscan Road from Springfield Ave., Hilton, N. J. 1838

It is difficult to locate homes in this very early postcard view of Tuscan Road in the Hilton section of Maplewood.

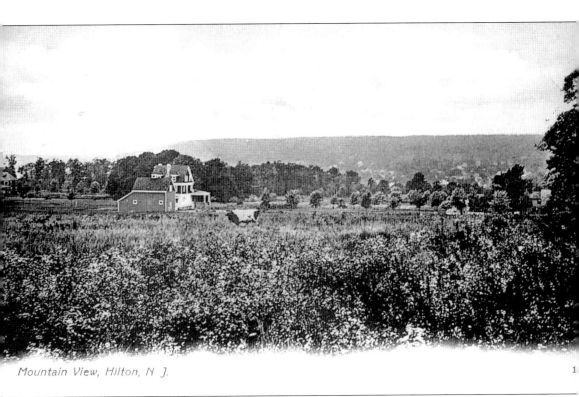

Mountain View, Hilton, N J.

This farm is in the Hilton section of Maplewood. South Mountain is pictured in the distance, and Maplewood Village is at its base.

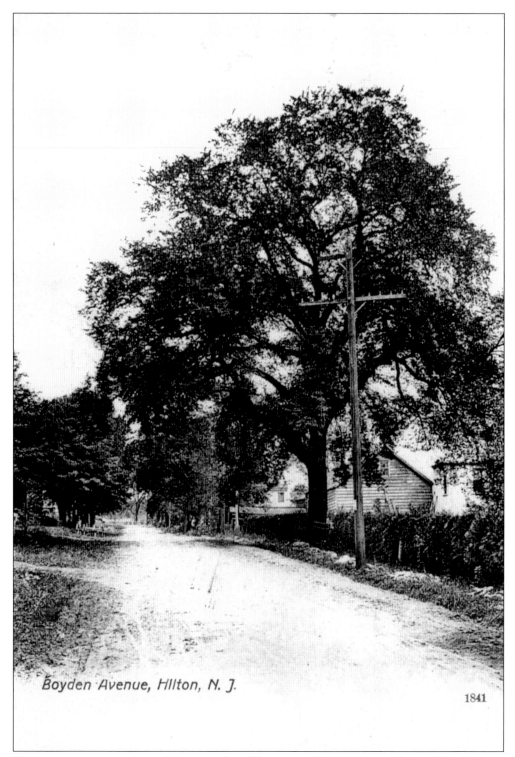

Boyden Avenue, Hilton, N. J.

1841

This huge oak tree stood guard for more than 100 years on Boyden Avenue in the Hilton section of Maplewood.

Two
COMMERCIAL
MAPLEWOOD

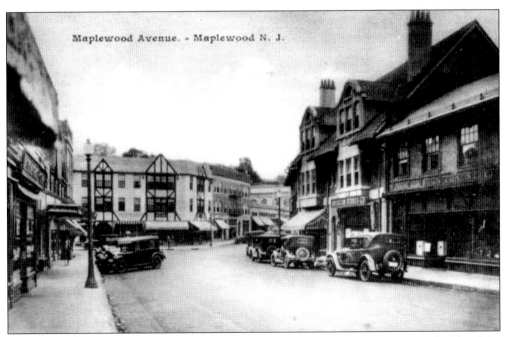

Maplewood Avenue is seen in a view looking northeast. Some of the cars are parked head-in, similar to how it is today. Also note the gas streetlights, which were used until the 1920s.

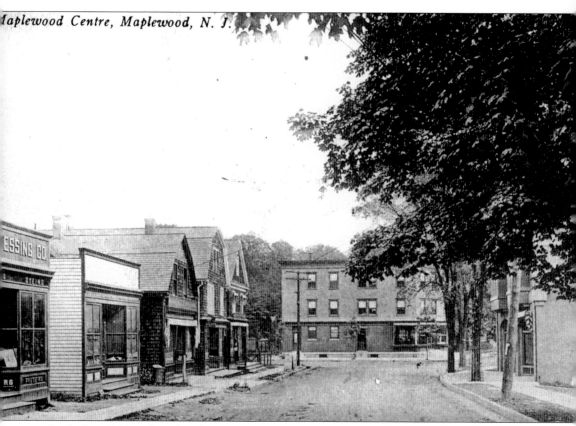

In the late 1890s, when this photograph was taken, many of the buildings in Maplewood Centre were primarily residential. They were subsequently converted for commercial use as the town grew. Note the two children on the far right.

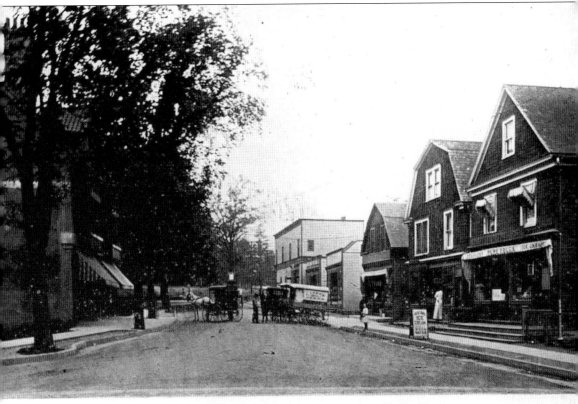

MAPLEWOOD AVE., Maplewood, N. J.

The opposite view of Maplewood Avenue, looking west, indicates that Garret Byrnes Pharmacy has moved from Baker Street to the building on the left in this view. The pharmacy printed many early Maplewood postcards.

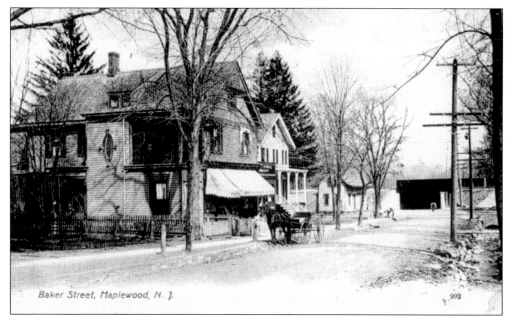

Baker Street, Maplewood, N. J.

This early postcard shows Baker Street in a view looking east toward the railroad overpass. On the left are the H.J. Baker store and Garret Byrnes Pharmacy. The small building at the end on the left served as the Maplewood train station beginning in 1902.

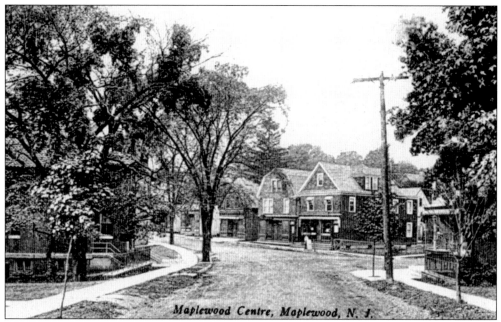

Maplewood Centre, Maplewood, N. J.

This 1913 view of the intersection of Maplewood Avenue and Highland Place looks south. The building on the left is the original post office.

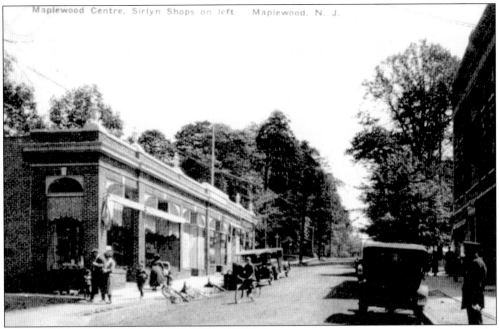

This busy scene looking north on Maplewood Avenue shows the Sirlyn Shops building on the left, which was built in 1925 and still exists today.

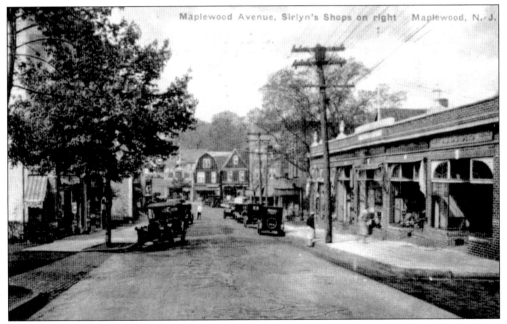

This view of Maplewood Avenue looks south at the intersection of Inwood Place. The building on the left houses Village Coffee today.

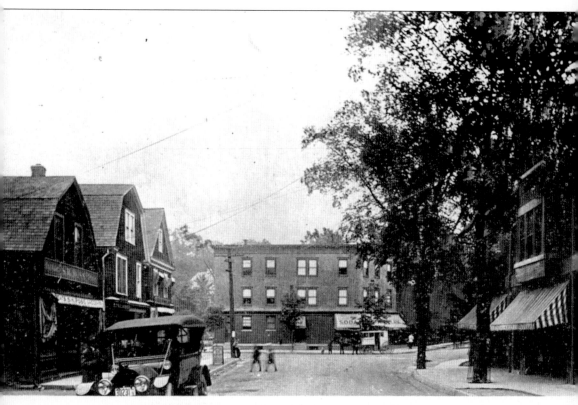

MAPLEWOOD AVE., Maplewood, N. J.

The contrast in the means of travel at this time can be seen by the automobile in the front and the horse and buggy toward the center rear of the photograph. This scene is at the intersection of Maplewood Avenue and Highland Place. The building on the left houses Samuel H. Ross, which operated as a meat market and grocery starting in 1905.

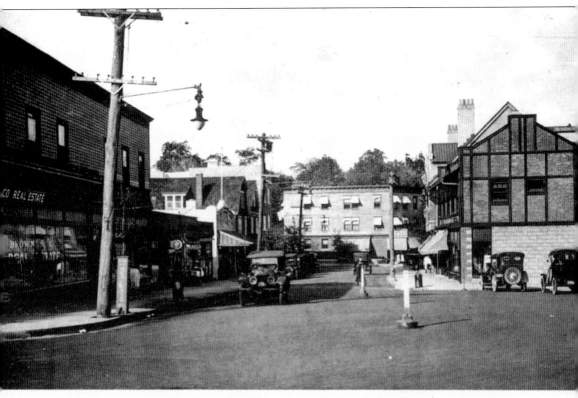

A VIEW OF THE BUSINESS CENTRE. MAPLEWOOD, N. J.

Brown Company Real Estate can be seen on the left in this view of Maplewood Avenue, looking north. Note the gas pump at the curb near the light pole.

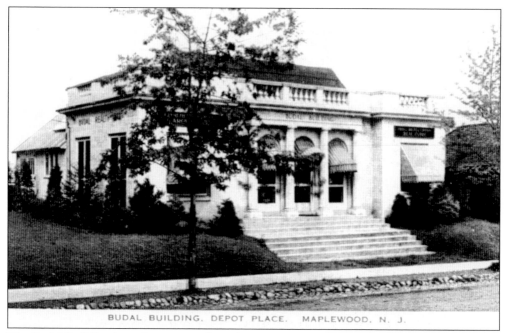

BUDAL BUILDING, DEPOT PLACE, MAPLEWOOD, N. J.

The Budal Building is at the corner of Maplewood Avenue and Depot Place, near the current railroad station. Renovations over time have hidden much of the detail, but remnants of the original building can be seen at the roofline of the building next to Valley National Bank today.

The cars in this hand-colored view are parked on the north side of Valley Street, just beyond Jefferson Avenue. The store on the corner is 509 Valley Street and houses a hair salon today. Herb, the sender of the card, noted his residence with an X on the card.

PEACE

in the nursery

All can be quiet on the nursery front now that Vi-Penta Drops can abolish the daily cod liver or other vitamin fish oil battles. For infants and children who cannot swallow capsules, or tolerate nasty tasting or fishy preparations, **we highly recommend Vi-Penta Drops, the only 5-vitamin liquid obtainable. They** contain all five important vitamins in a highly concentrated, fine-tasting, clear liquid with a nice orange odor. May be administered in milk, orange juice, broth, or other foods without fear of detection. We, of course, also carry large supplies of Vi-Penta Perles.

We gladly offer our services in the preparation of your prescriptions.

MATTER'S DRUG STORE
1755 Springfield Ave.
Phone S. O. 2-4471 MAPLEWOOD, N. J.

Postcards were also used to provide information on products and market them to the public. On this card, Matter's Drug Store, on Springfield Avenue in Maplewood, is promoting "Peace in the Nursery" by using Vi-Penta Drops.

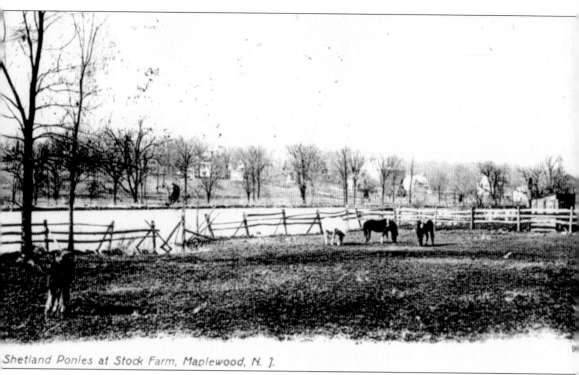

Shetland Ponies at Stock Farm, Maplewood, N. J.

When this postcard was mailed in 1905, this Shetland pony stock farm was located near Pierson's Mill on Baker Street.

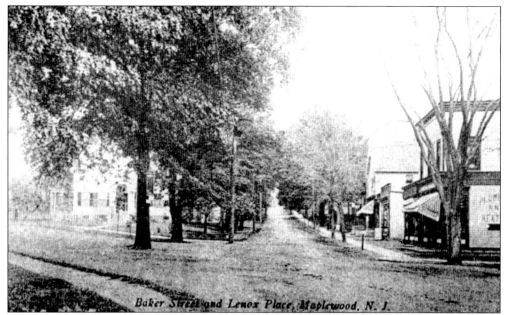

Lenox Place is shown in a view looking west. The house on the left originally faced Maplewood Avenue and was subsequently moved to its current address at 1 Lenox Place.

Mailed in 1947, this card promotes "Maplewood—the Theatre Distinctive." The inscription on the back reads, "Programs follow directly after first run in City of Newark, and === convenient to you."

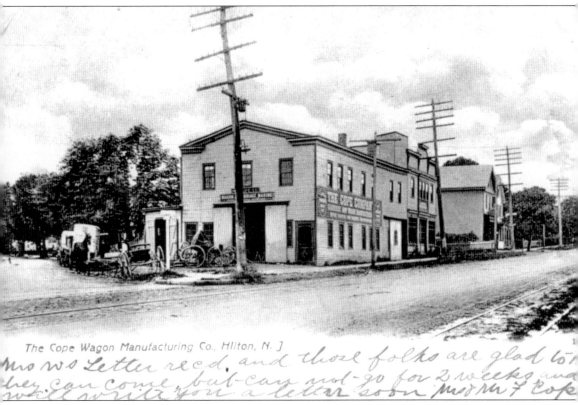

The Cope Wagon Manufacturing Co., Hilton, N. J.

Mrs Ws Letter rec'd, and those folks are glad to they can come, but can not go for 2 weeks and will write you a letter soon Mr & Mrs F Cope

This card was mailed in 1907 by Mr. and Mrs. Cope, the owners of the Cope Company, which started in 1887. The company specialized in making horse carriages and was located in the Hilton section of Maplewood at the intersection of Springfield and Boyden Avenues.

The Marcus L. Ward Home was built in 1927 on 49 acres of land bounded by Boyden and Elmwood Avenues. It was initially opened as a free home for 80 residents—gentlemen in need. Since that time, a major development effort has expanded the residency significantly.

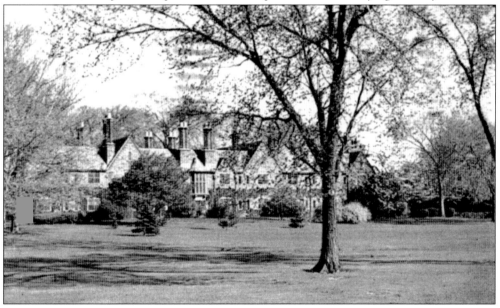

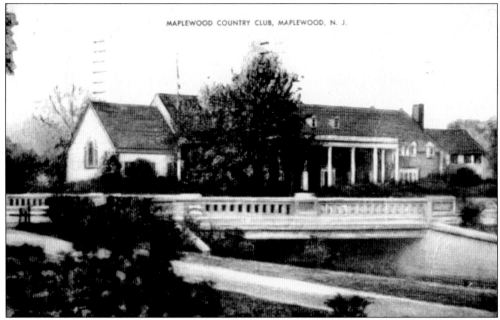

The privately owned Maplewood Country Club is located on Baker Street at the site of the old Maplewood Field Club, across from the main branch of the Maplewood Public Library.

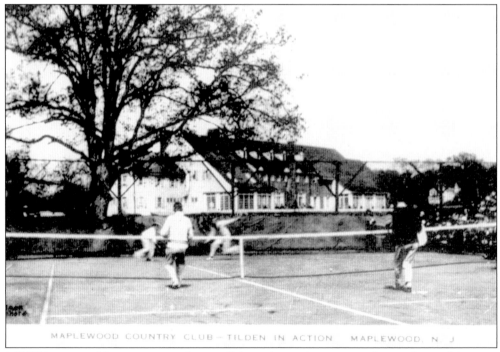

Bill Tilden, one of the great tennis players of his era, is seen in action on the Maplewood Country Club tennis courts.

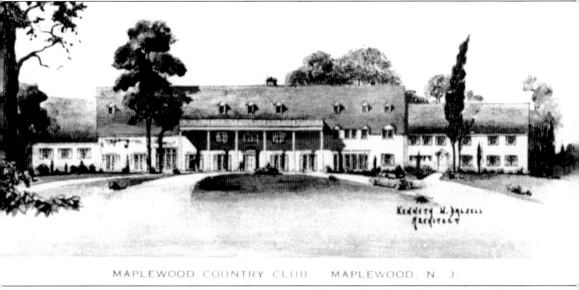

MAPLEWOOD COUNTRY CLUB. MAPLEWOOD, N. J.

This architect's rendering of the Maplewood Country Club identifies the architect as Kenneth W. Dalzell. The sender of the card noted on November 10, 1922, that the new club was nearly finished.

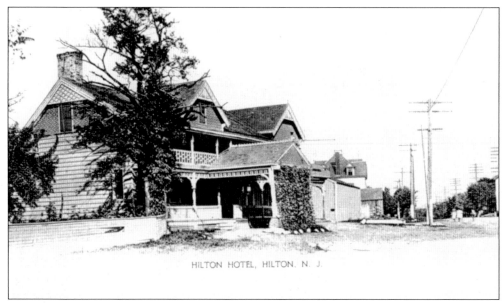

HILTON HOTEL, HILTON. N. J.

The Hilton Hotel was located at the intersection of Springfield Avenue and Burnett Street. Joseph Pfau owned it in the late 1800s, when Maplewood was a favorite destination for day-trippers from Newark.

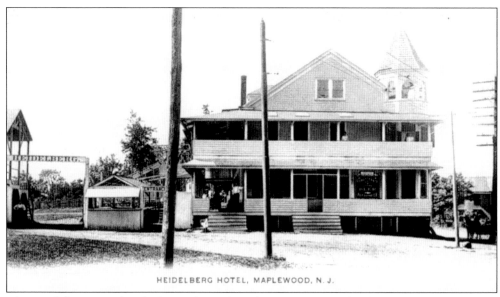

HEIDELBERG HOTEL, MAPLEWOOD, N. J.

The Heidelberg Hotel, which was located at the intersection of Valley Street and Millburn Avenue, was another destination for travelers looking for a room for the night or a cold beer.

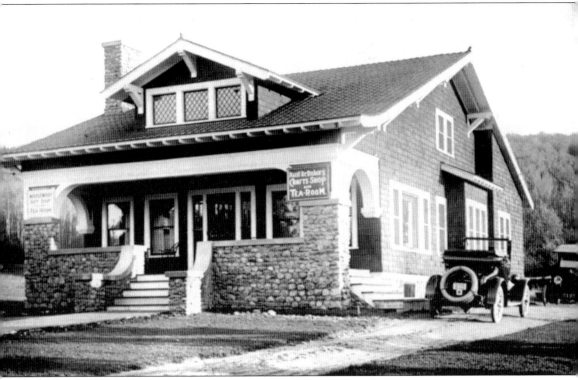

Paul Rehnborg's Gift Shop and Tea Room is believed to have been located near the rise to South Mountain.

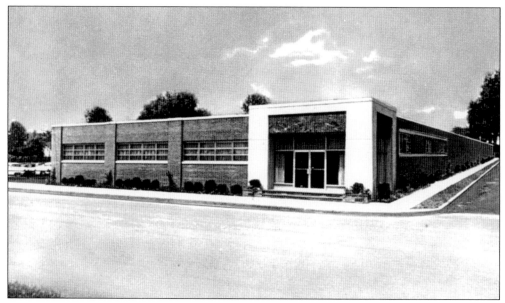

This photochrome postcard depicts the new home of the Artcraft-White Ace Company as of 1932. The building was located at the intersection of Springfield Avenue and Colgate Road.

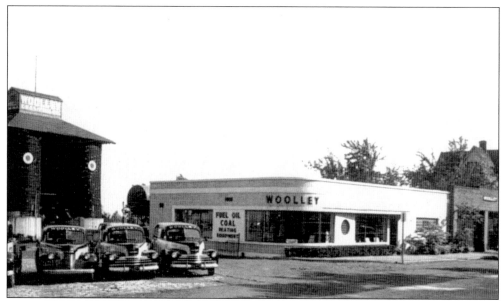

The Wooley Fuel Oil Company has a long history in Maplewood, and its legacy continues today.

Three
GETTING AROUND

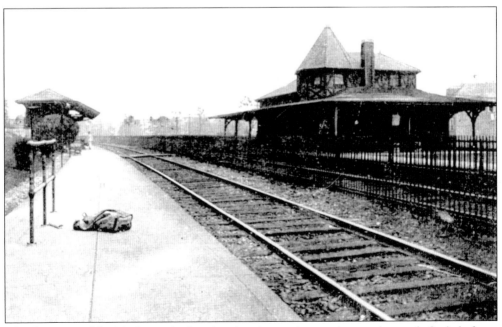

This dim view of the Maplewood railroad station shows a luggage bag on the westbound platform.

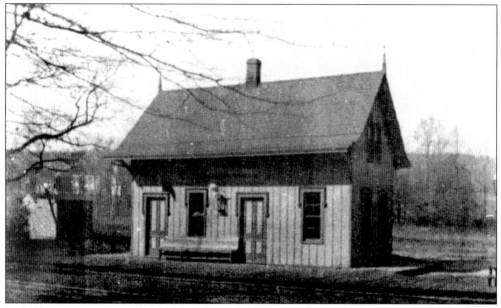

This card commemorates the first Maplewood railroad station, which was in use from when it was built in 1860 until 1902. It was situated on the northwest side of the tracks near Baker Street.

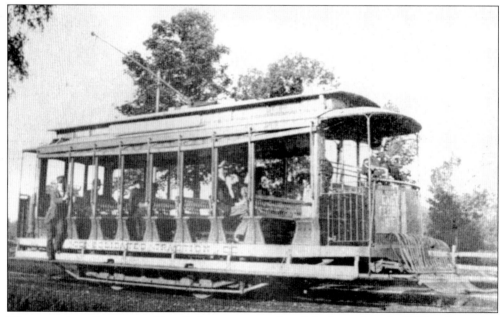

The open-air trolley was used locally in warmer weather. It is shown here in 1905 at the passing track on Valley Street, near the present town hall. As noted on the trolley, it was owned by the Consolidated Traction Company.

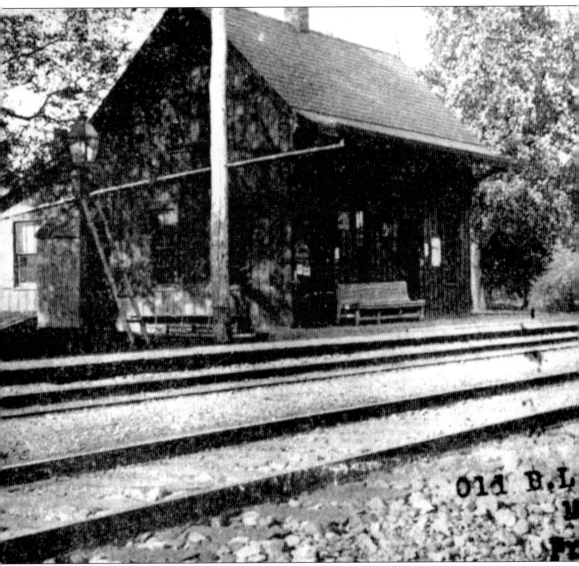

This is another very early view of the original Maplewood railroad station. Seth Boyden invented and built the first engines for the railroad in 1838.

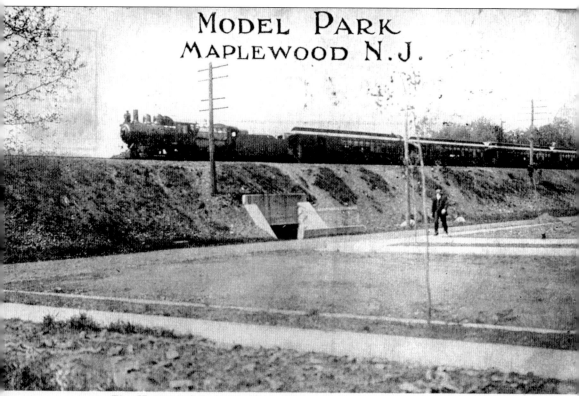

MODEL PARK
MAPLEWOOD N.J.

The Home-seekers' Paradise. Terminus Springfield Ave. Trolley.

A series of five postcards was created to promote "Model Park—the garden spot of Essex County." This 1910 scene shows the train heading west. The monthly fare to Hoboken at the time was $6.90.

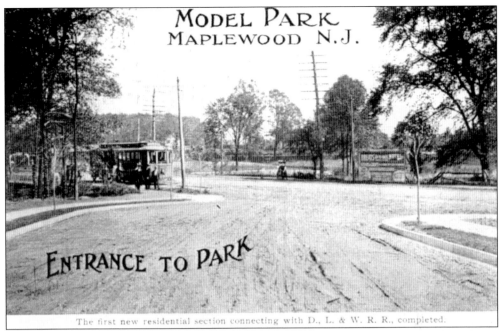

MODEL PARK
MAPLEWOOD N.J.

ENTRANCE TO PARK

The first new residential section connecting with D., L. & W. R. R., completed.

Around the time this card was mailed in 1909, Model Park had become a reality and was being touted as "the first new residential section connecting with the railroad."

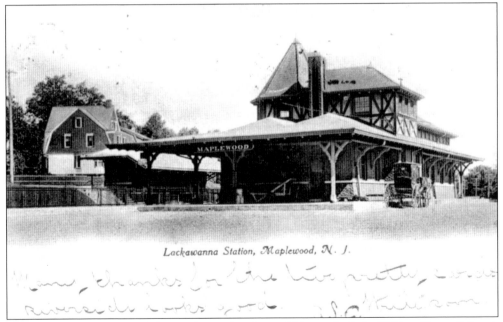

Lackawanna Station, Maplewood, N. J.

This is a very early scene of the Maplewood station, which was built in 1902 on Dunnell Road. The horse-drawn buggy is most likely waiting for commuters arriving from Hoboken. The card was mailed in 1905, when messages were not permitted on the back of postcards. The home on the left is located at 140 Maplewood Avenue (also seen on page 22).

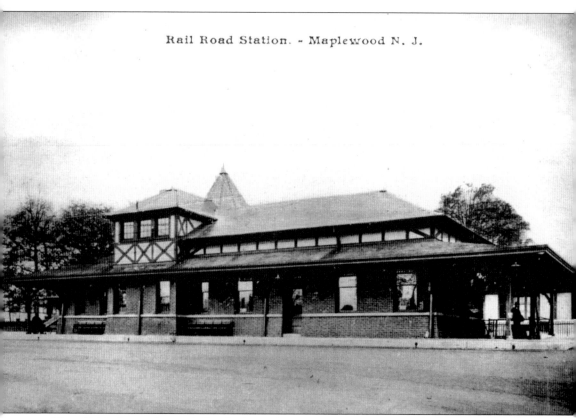

Rail Road Station. - Maplewood N. J.

The old Maplewood town hall, which was located on Maplewood Avenue, can be seen in the distance to the left of the railroad station around the time it was torn down in 1932.

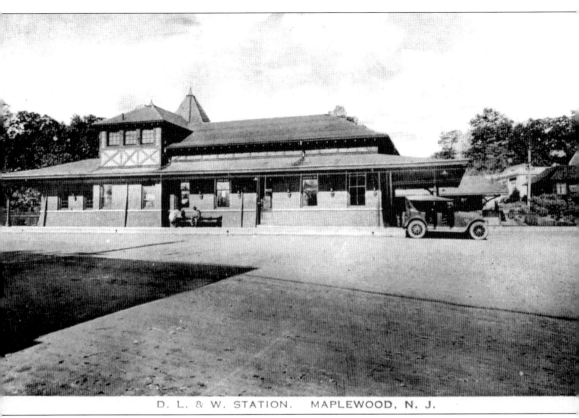

D. L. & W. STATION. MAPLEWOOD, N. J.

An automobile signals this later view of the railroad station. The Budal Building (page 62), at Depot Plaza, can be seen to the right of the station.

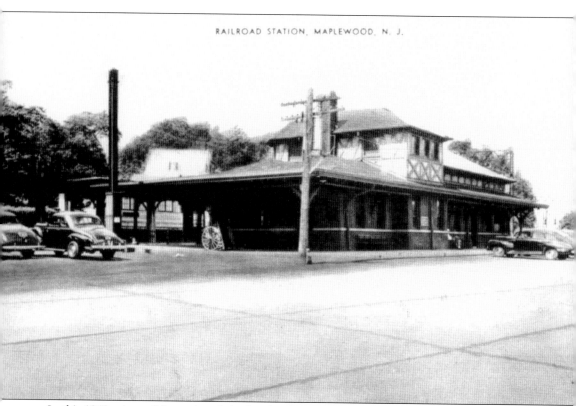

In this 1940s view of the station, it is clear by the number of commuter cars that the popularity of the train as a means of commuting has increased.

Four

PUBLIC SERVICE

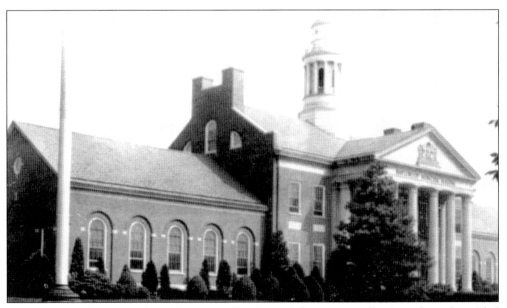

The Maplewood Municipal Building, on Valley Street, is home to a collection of murals entitled *The History of Maplewood,* painted by Stephen Juharos in 1958–1959.

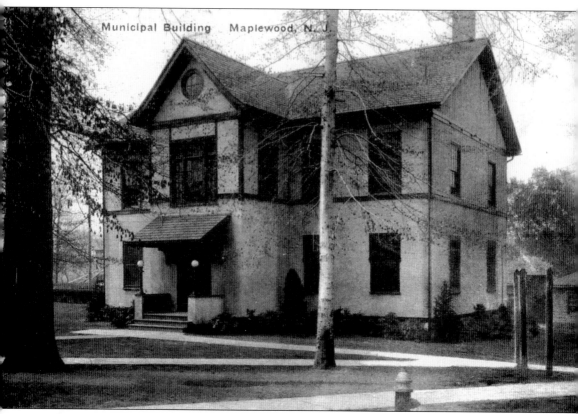

The original town hall is seen in this view from 1911. The building served as the town hall from 1904 to 1932 and was located on the east side of Maplewood Avenue between Highland Avenue and Baker Street.

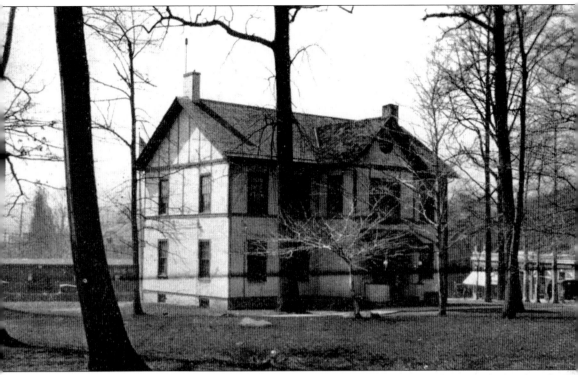

In this hand-colored view of the original municipal building, the stores located on Maplewood Avenue can be seen in the background.

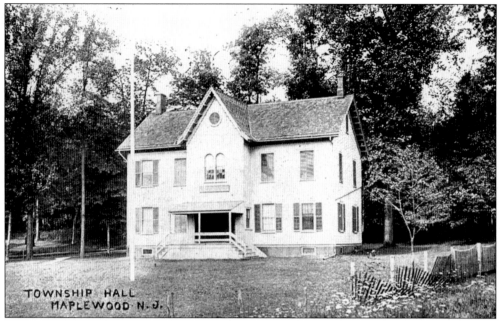

The rear of the town hall is shown here. Built in 1868 as Maplewood's first consolidated school, the building became the town hall in 1904 and the old library in 1932.

This later image of the original town hall was taken when the building was being used as a library.

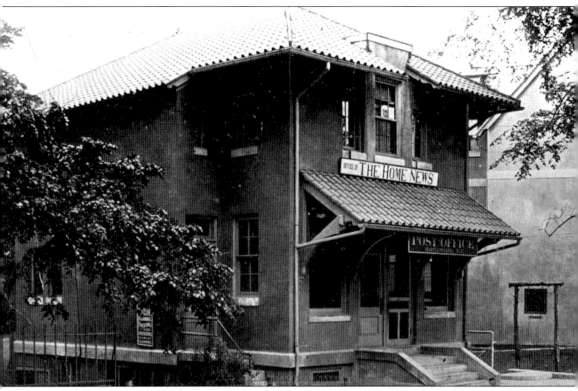

Maplewood's first post office was also the "office of the Home News," as noted on the sign. It was located on the east side of Maplewood Avenue. Today, the roofline of the building can be seen behind newer renovations.

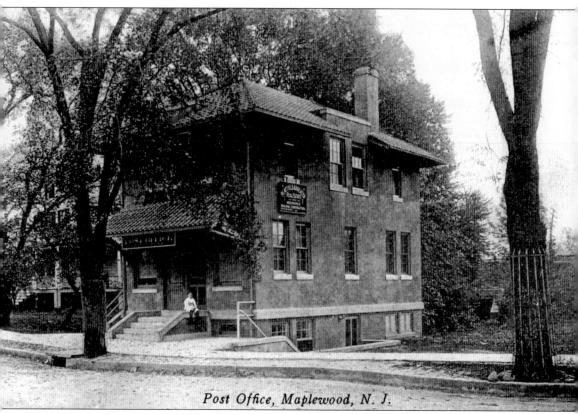

Post Office, Maplewood, N. J.

This earlier, reverse view of the post office shows the building's proximity to the railroad tracks in the background. The sign on the side of the building advertises Platt & Leadbeater Real Estate.

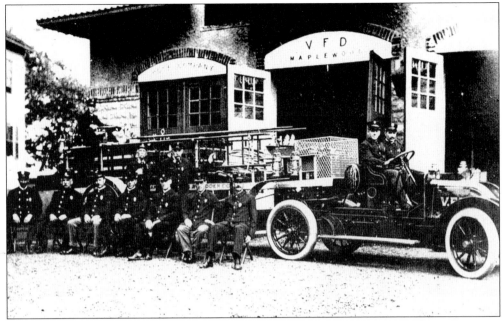

The first Maplewood Hook and Ladder Company motor equipment was purchased in 1913. Here, it is shown in front of the old fire department building on Maplewood Avenue, where the Maplewood post office is located today.

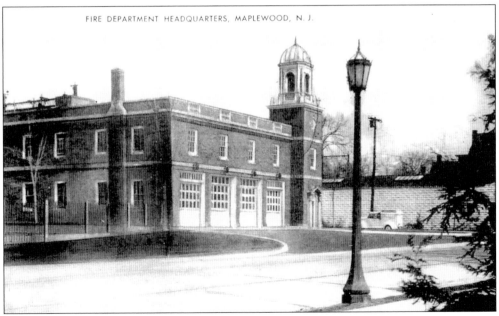

The current fire department headquarters was built on Dunnell Road in 1924. Ironically, it was built on the former site of the Dunnell Paper Mill, which after having two serious fires, burned to the ground in a fire in 1892. Note the Good Humor truck in the driveway.

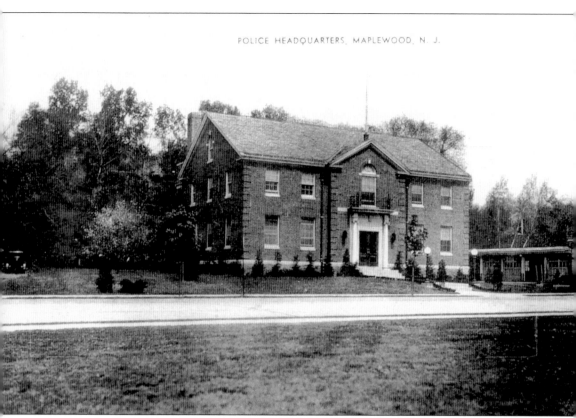

The police department was organized in Maplewood on May 1, 1906, and Jacob Deffur, Dennis Maher, and Arthur Boyle served as the first police officers. Boyle became captain of the department in 1910. The current police headquarters building was built on Dunnell Road in 1930.

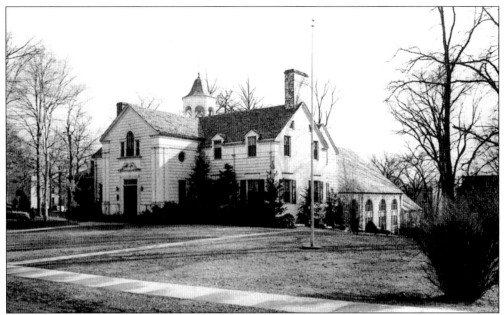

The Woman's Club of Maplewood building was erected in 1930 on Woodland Road near Maplewood Village. The club was founded in 1916.

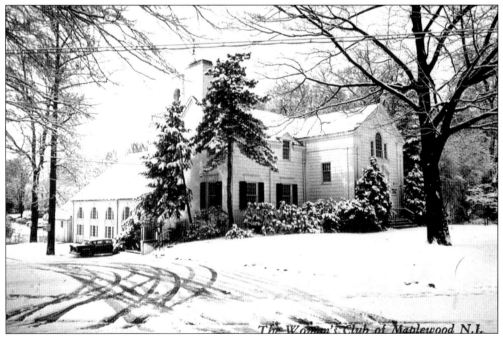

The Woman's Club building, pictured on a winter day on this photochrome postcard, is used for many other organizations' meetings, special events, and religious services.

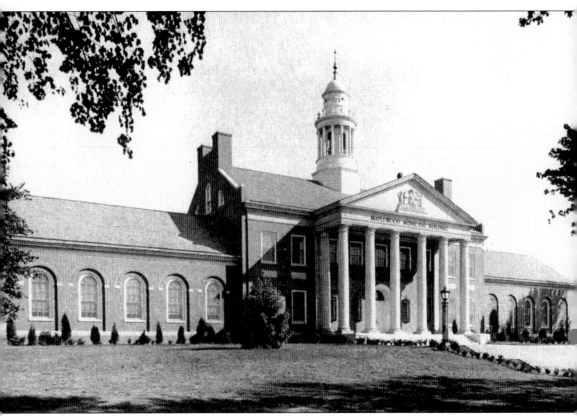

The current municipal building, on Valley Street, was dedicated in 1931 to the "promotion of good government and civic consciousness." The building has become a recognizable symbol of Maplewood. It was built on land that was originally the Henry S. Smith estate.

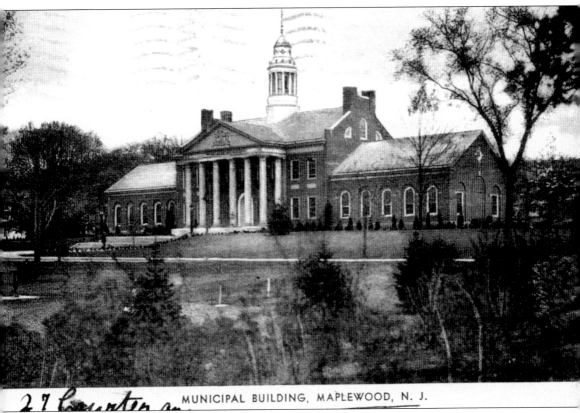

2 7 Courter av MUNICIPAL BUILDING, MAPLEWOOD, N. J.

This much earlier view of the municipal building was taken from Memorial Park, clearly before the area where the sports fields in the park are today was cleared.

Baker St. showing Maplewood Sporting Club, Maplewood, N. J.

will be with you Thursday
E.

The Maplewood Sporting Club was a community fixture in Maplewood at the beginning of the 20th century. It was the site of many town events, including the Fourth of July celebration. It was located where the Maplewood Country Club is today. On this card, postmarked September 4, 1906, the sender wrote, "Will be with you Thursday. E."

Five

HALLS OF LEARNING

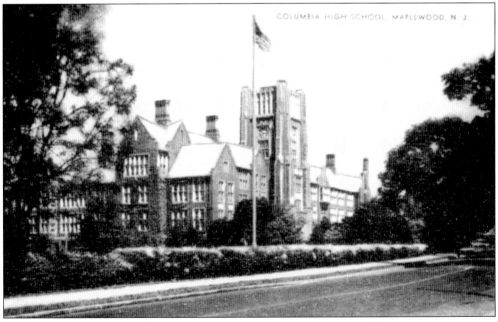

Featured here is Columbia High School, located at Parker Avenue and Valley Street.

Public School, Hilton, N. J.

The Middleville School was built in 1881 and was in use as a school until 1913. It was located on the corner of Boyden Avenue and Academy Street (Tuscan Road today).

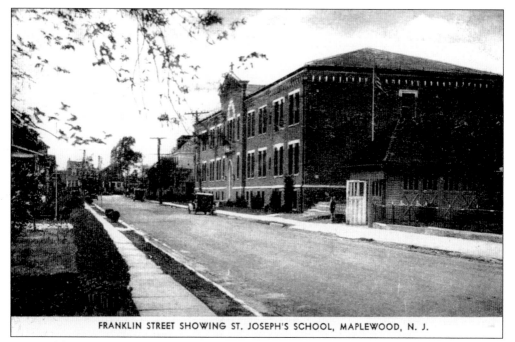

FRANKLIN STREET SHOWING ST. JOSEPH'S SCHOOL, MAPLEWOOD, N. J.

St. Joseph's Roman Catholic School was the first parochial school in Maplewood when it was built in 1930. It is located on Franklin Avenue, in the Hilton section of Maplewood.

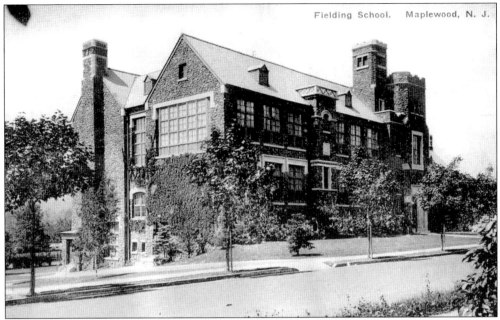

The Fielding School was located on Academy Street, just north of Columbia High School. Today, the building is used as the administrative offices of the Maplewood–South Orange Board of Education.

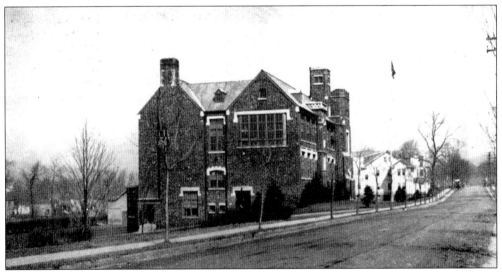

This earlier hand-colored postcard of the Fielding School shows a view looking north on Academy Street. Note the horse and buggy in the distance. The card, postmarked November 30, 1931, shares that the sender had "driven over the new suspension bridge . . . and back through the tunnel."

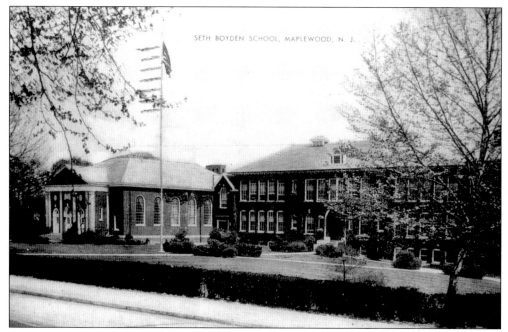

Seth Boyden School was built in 1913 on Boyden Avenue, just off Springfield Avenue. The school is named after Seth Boyden, the famous inventor who lived just down the street from 1855 until his death in 1870. In the 1860s, Seth Boyden developed the cultivated strawberry.

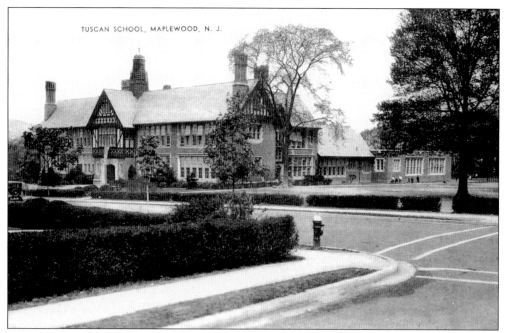

The Tuscan School, built in 1924, is located on Tuscan Road between Prospect and Valley Streets. The school and the street are named after the Native American chief Tuscan, who lived in this valley in the 1600s. Legend places his campsite by the stream near the Tuscan School.

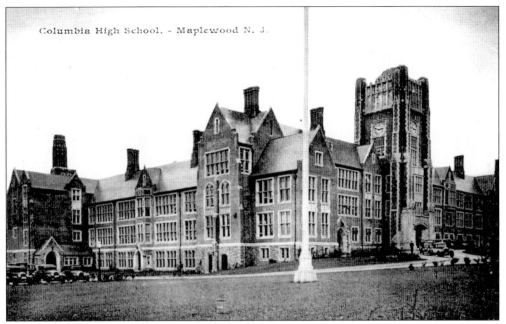

Columbia High School accepted its first class of students in 1927. The high school serves students from both Maplewood and South Orange. It is located at the intersection of Valley Street and Parker Avenue. Note the vintage cars at the front entrance.

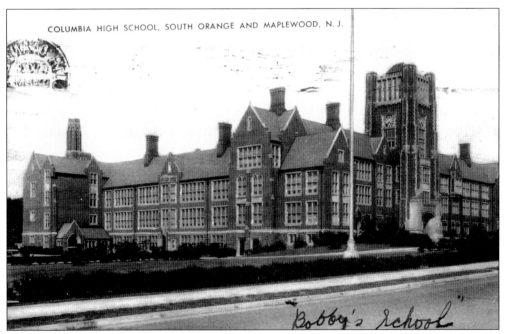

Referred to as a "Bobby's School" by this sender, the high school cost $2 million to build and was featured in *Encyclopedia Britannica* at that time.

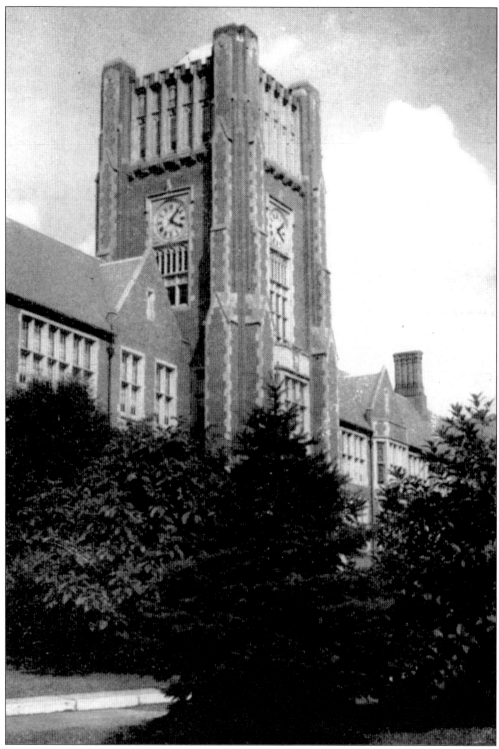

The Columbia High School tower above the clock contains an observatory for watching the solar system.

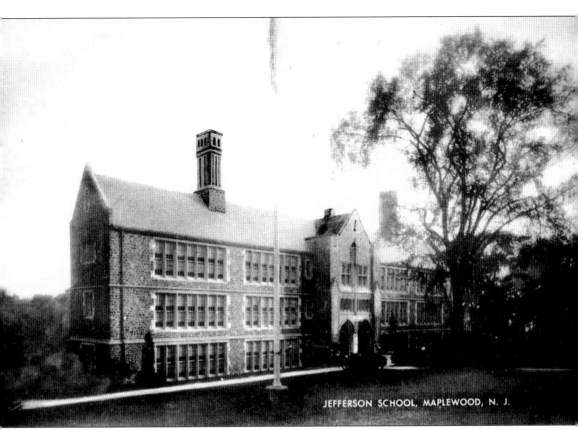

JEFFERSON SCHOOL, MAPLEWOOD, N. J.

Jefferson School on Ridgewood Road was built in 1922. Several additions over the years have dramatically increased the size of the school.

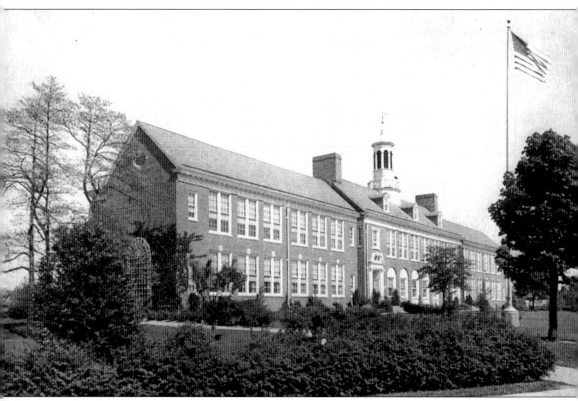

The Clinton School is located on Berkshire Road and was completed in 1928.

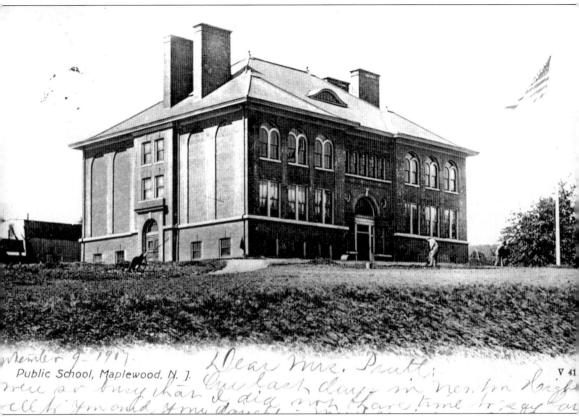

This is a very early view of Ricalton Public School, now named Maplewood Middle School. The original school consisted of eight rooms. Note the landscapers working on the lawn.

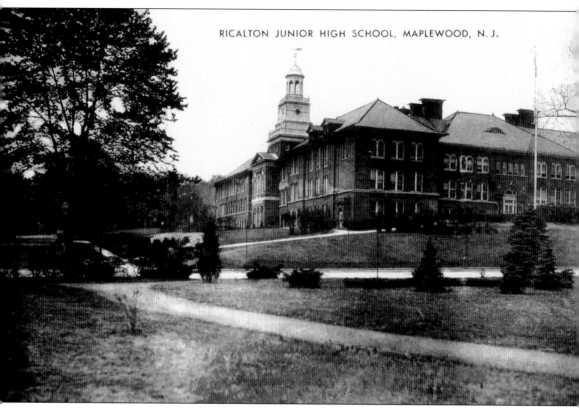

RICALTON JUNIOR HIGH SCHOOL, MAPLEWOOD, N. J.

This later view of Ricalton Junior High School from Memorial Park shows the first major addition to the school in the 1920s. Subsequent additions, including a gym, were added over time.

Six

PLACES OF WORSHIP

The first Methodist church in Maplewood was the Hilton Methodist Church, which was established in 1836. The building to the left is the Middleville School, which was torn down and is the church parking lot today. The church is active today on Boyden Avenue, across from Seth Boyden School.

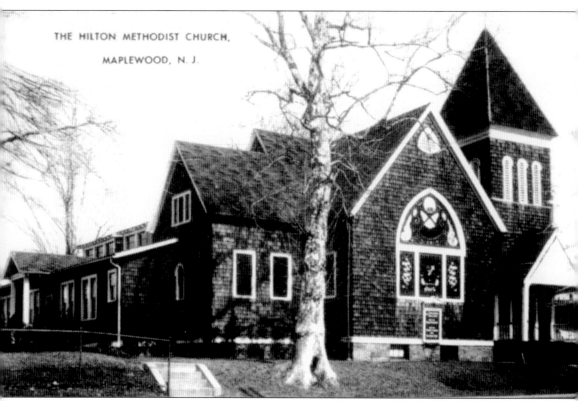

THE HILTON METHODIST CHURCH,

MAPLEWOOD, N. J.

A later view of the Hilton Methodist Church shows additions that were built on the left side of the church. Hilton Methodist Church was instrumental in the early 1900s in supporting blue laws and in limiting the number of taverns that were built on Springfield Avenue.

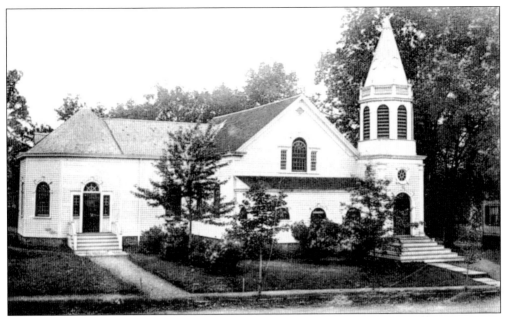

This church originally served as a Baptist church and meetinghouse on the corner of what is now Ridgewood Road and Claremont Avenue. It served as a Baptist church from when it was built in 1812 until 1846. It was deeded to the Methodists in 1858, who moved the building to Lenox Place, where a vestibule and bell tower were added.

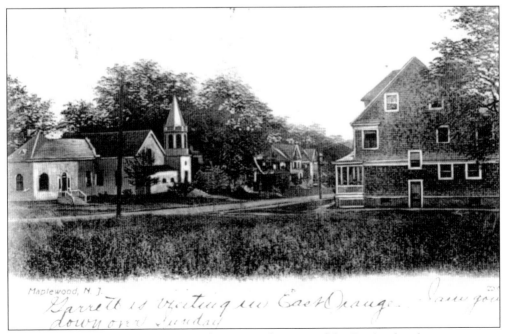

Residences on Claremont Avenue can be seen in this view of the Baptist church.

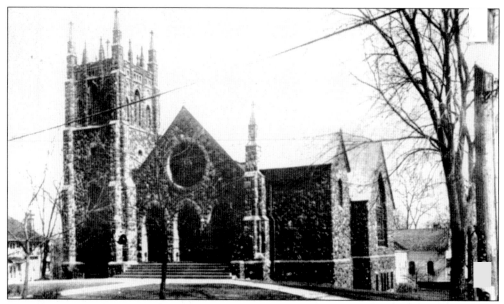

This is a view of the current Methodist church, which was named Morrow Memorial Methodist Church in 1897 after John I. Morrow, the pastor of the church at the time it was moved.

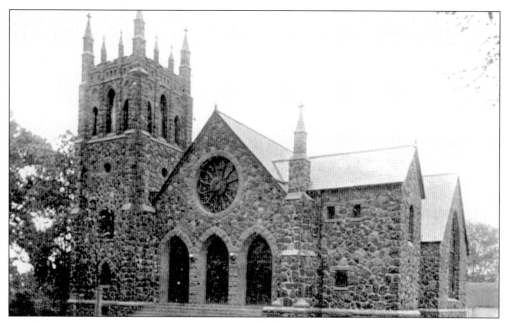

In this hand-colored postcard, the original Methodist church can be seen behind the newer Morrow Memorial Methodist Church.

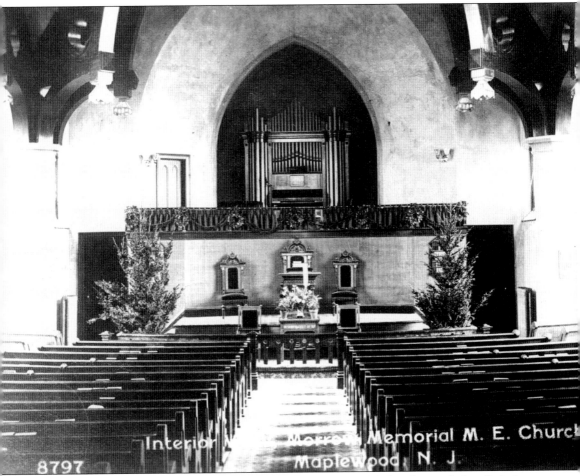

Interior ... Morrow Memorial M. E. Church
Maplewood, N. J.

8797

This interior view of Morrow Memorial Methodist Church highlights the newly installed pipe organ. The card was one of a series of postcards to celebrate the new church in the late 1870s.

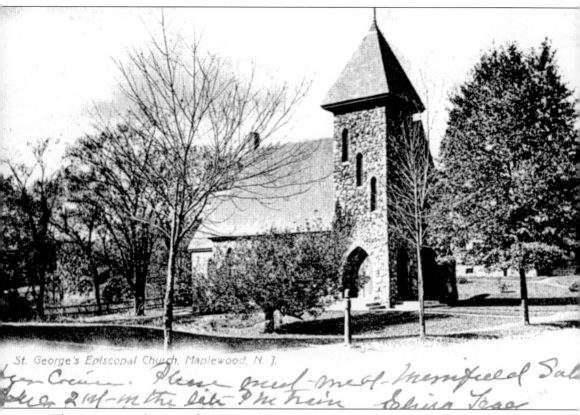

St. George's Episcopal Church, Maplewood, N. J.

This is a very early view of St. George's Episcopal Church at its original location on Clinton Avenue. The building was razed when the congregation moved to its new building on Ridgewood Road. The original location is now the site of two residences at 16 and 18 Clinton Avenue.

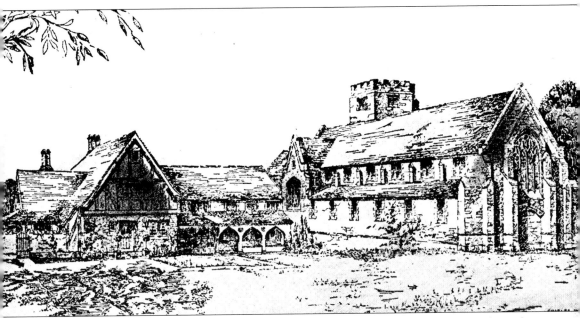

This postcard shows a sketching of the new St. George's Episcopal Church on Ridgewood Road. The parish hall (to the left) was completed in 1921. Services were held there until the stone church was completed in 1926.

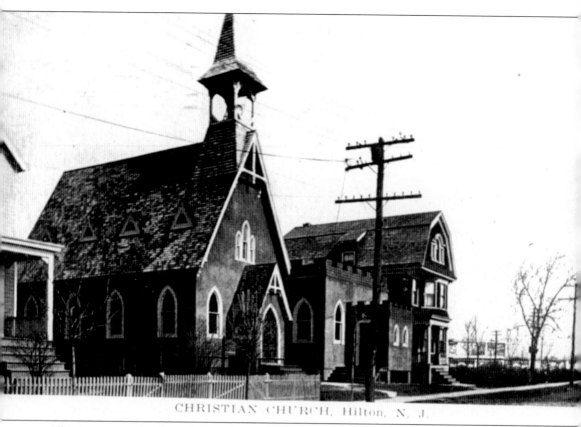

CHRISTIAN CHURCH, Hilton, N. J.

This is a very early view of the Hilton Christian Church, which was built in 1875. Springfield Avenue can be seen in the distance.

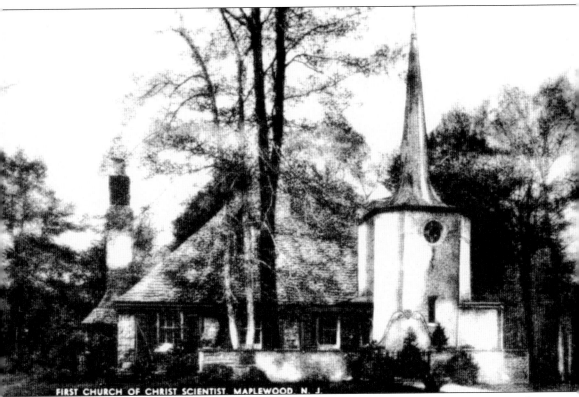

FIRST CHURCH OF CHRIST SCIENTIST, MAPLEWOOD, N. J.

Located on Durand Road, this building originally served as a church with a congregation of Christian Scientists at one time. It was ultimately purchased by Jean Burgdorff, who donated it to the town for use as a civic and cultural center. Today, it is Burgdorff Cultural Center.

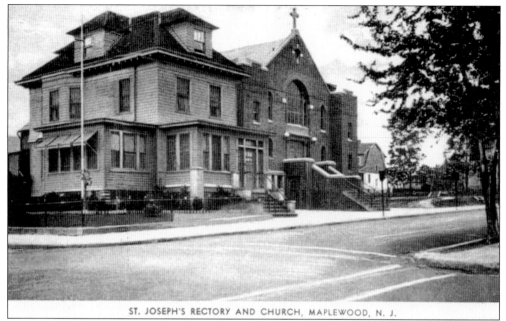

ST. JOSEPH'S RECTORY AND CHURCH, MAPLEWOOD, N. J.

St. Joseph's Roman Catholic Church was organized in 1914 by parishioners from Newark. The church building was completed in 1922 on Prospect Street. The house to the left, which served as the parish house, was subsequently torn down.

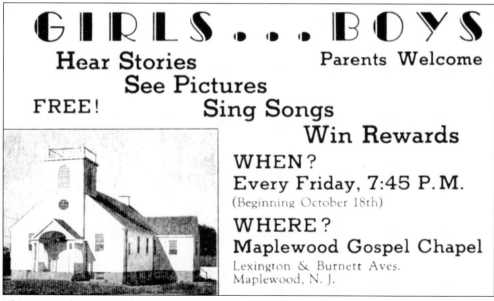

This postcard invites girls and boys to come every Friday night to the Maplewood Gospel Church, which was located at Lexington and Burnett Avenues.

THE FIRST PRESBYTERIAN CHURCH OF WYOMING, N. J.

Wyoming June 23/'13

Dear Sister (+Father) am sending you a small top by parcel Post hope you get it all O.K. and tell me what you think of it. R + V. both passed in all exams

The First Presbyterian Church was located on Ridgewood Road at the Maplewood-Millburn border.

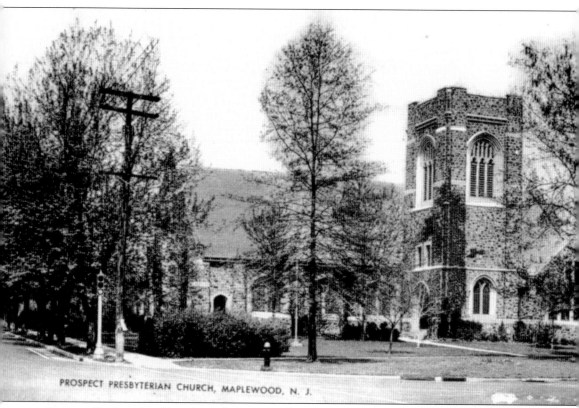

PROSPECT PRESBYTERIAN CHURCH, MAPLEWOOD, N. J.

Prospect Presbyterian Church, at the corner of Prospect Street and Tuscan Road, was built in 1926. In 1946, a stained-glass window was dedicated for those who served in World War II.

Seven
Maplewood at Play

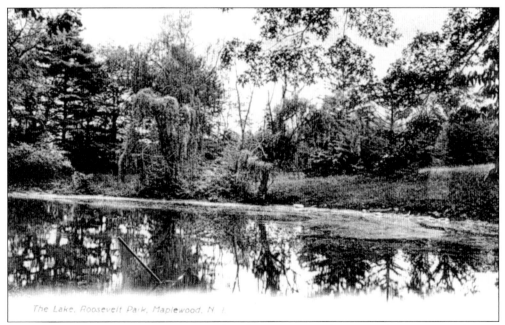

The Lake, Roosevelt Park, Maplewood, N. J.

The lake, or "Teddy's Pond," as depicted in the message on this postcard in 1908, was located on the Roosevelt estate. In the winter, frozen blocks of ice were cut from the ice and stored in a shed with hay as insulation for use in the summer. The unfortunate death of a young boy in the pond led to an order from the town to drain the pond.

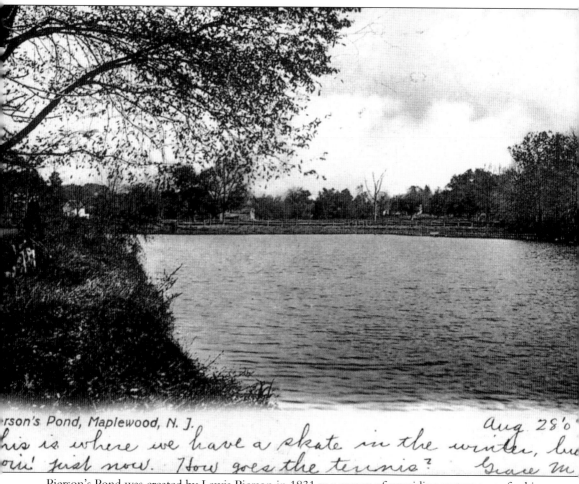

rson's Pond, Maplewood, N. J.

his is where we have a skate in the winter, but
oin' just now. How goes the tennis? Grace M

Aug 28 '0

Pierson's Pond was created by Lewis Pierson in 1831 as a means of providing waterpower for his gristmill. The pond was a favorite destination in the winter for ice-skaters. The pond was used commercially until 1909 and was drained in 1916. It was located along the Valley Street border of the Maplewood Country Club.

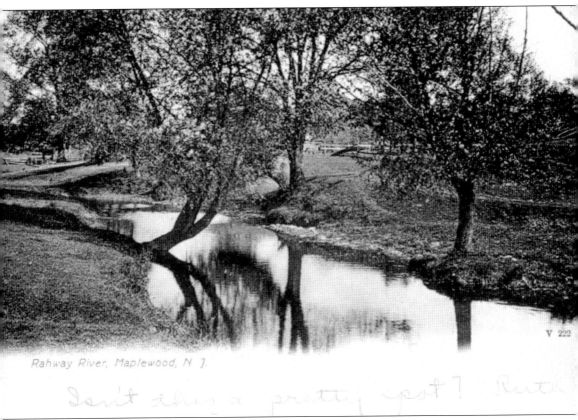

Rahway River, Maplewood, N. J.

V 222

Isn't this a pretty spot? Ruth

This message on a postcard from a scene along the Rahway River says it all: "Isn't this a pretty spot?"

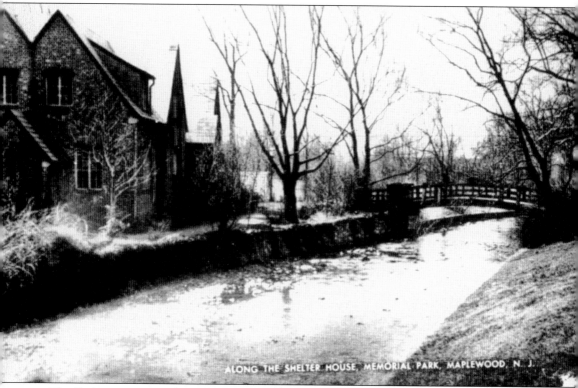

ALONG THE SHELTER HOUSE, MEMORIAL PARK, MAPLEWOOD, N. J.

The Shelter House (on the left) is located off Dunnell Road and is used today as the Maplewood Recreation Department's home base. The message to David from Charlie describes life for kids in town: "We can roll down hills on the grass. You will see it some time. Get big quick. Charles and Douglas."

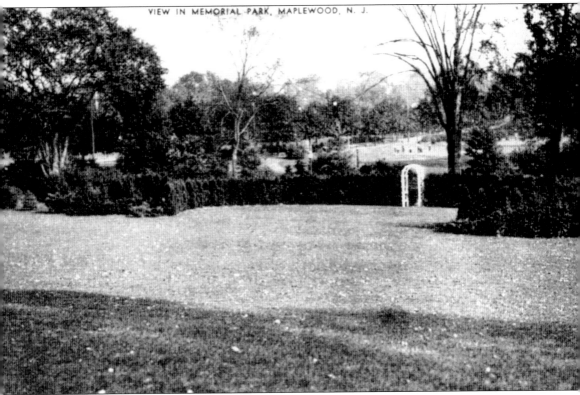

Maplewood has been known for its wonderful parks for many years. The park system was designed by Holmshead. This view is of today's amphitheater, across from the train station. The site is used for concerts in the summer and for great sleigh runs in the winter.

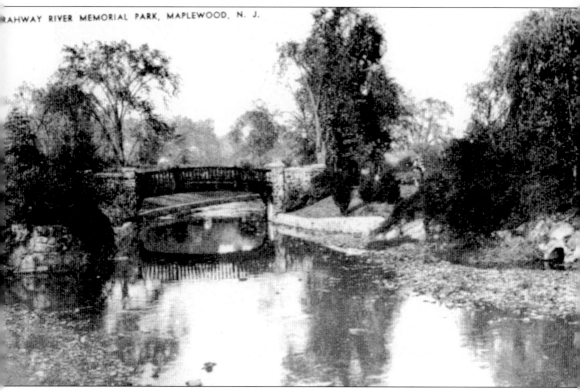

This is a scenic 1956 view of the Rahway River flowing through Memorial Park. The spot has been the scene of many wedding pictures over the years.

A scene along a brook in South Mountain Reservation provides the backdrop for a scenic ride in a horse-driven carriage. One-third of Maplewood is situated inside the reservation.

A pool created by the Rahway River provided a way to cool off in the summer months.

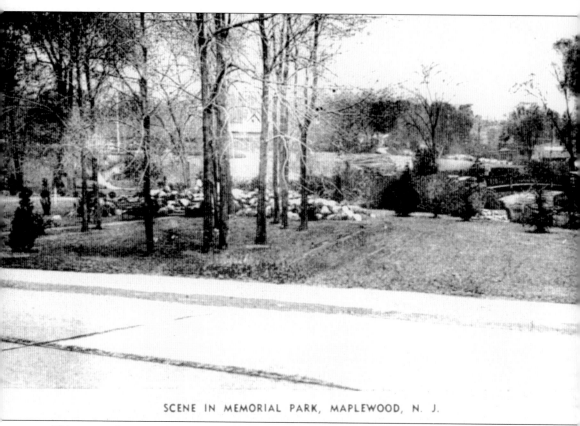

SCENE IN MEMORIAL PARK, MAPLEWOOD, N. J.

This scene of Memorial Park off Baker Street is across from the Maplewood Country Club. Note the two buildings in the distance: the train station (to the left) and Nelson's Garage (to the right).

Baker Street, Maplewood, N J.

Thanks 4 the Green remembrance.
Not going to Nutley. Bestus, Ethel

The Maplewood Field Club can be seen in this view of Baker Street. The Field Club building was originally a bicycle shop. The homes in the distance to the left were located on Valley Street. The writer is thanking someone for a gift in a way that is reminiscent of today's Internet lingo. The word "green" perhaps means money.

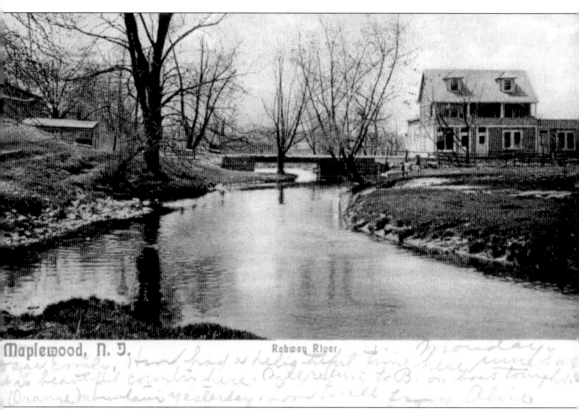

Maplewood, N. J.　　　　Rahway River

This view of Baker Street shows young explorers on the bank of the river. The Maplewood Field Club (in the distance) was the scene of many town events, including the Fourth of July celebration in 1918, when 4,000 people observed World War I military exercises.

This brook scene could have been taken anywhere in Maplewood in 1902. Most likely it is near Jefferson Avenue at the time the town's water system was installed, reducing the flow of water in the river.

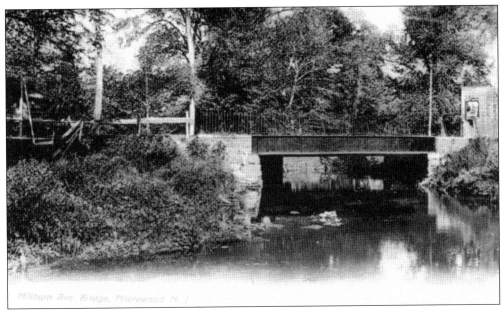

The Millburn Avenue bridge provides an idyllic passage for the Rahway River.

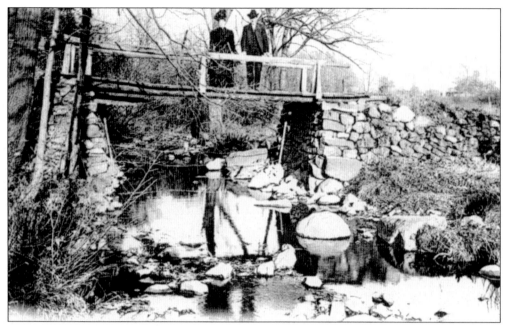

The people in this view show off the garb of the period. The postcard was mailed in 1911.

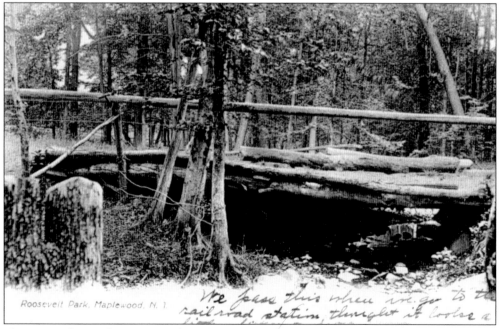

Roosevelt Park, Maplewood, N. J.

This postcard view from Roosevelt Park on the Roosevelt estate includes a message indicating the spot is not far from the train station.

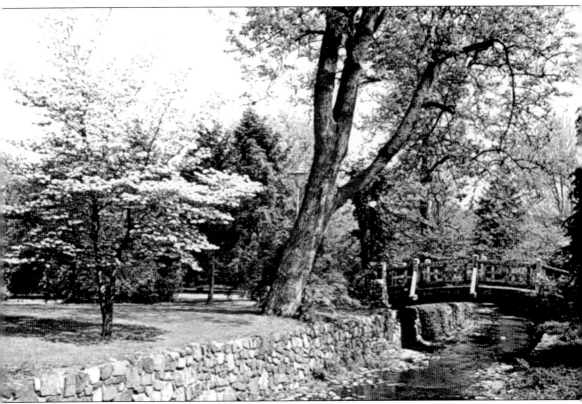

A more recent view of Memorial Park on a photochrome postcard shows that little has changed over the years. A streetlight and the new retaining wall are alongside the river.

This humorous postcard from the early 1900s was printed in bulk and could be modified to accommodate the name of any town.